EXHIBITION ITINERARY

FREDERICK R. WEISMAN ART MUSEUM

University of Minnesota, Minneapolis

June 4–August 31, 1997

PALMER MUSEUM OF ART

Pennsylvania State University, University Park

September 30–December 14, 1997

FREDERICK R. WEISMAN MUSEUM OF ART

Pepperdine University, Malibu, California

May 23–August 2, 1998

NEWCOMB ART GALLERY

Tulane University, New Orleans, Louisiana

October 5–December 20, 1998

THE FRED JONES JR. MUSEUM OF ART

University of Oklahoma, Norman

January 22–March 7, 1999

THE PARRISH ART MUSEUM

Southampton, New York

April 11–June 20, 1999

MEMPHIS BROOKS MUSEUM OF ART

Memphis, Tennessee

August 15–November 20, 1999

NORTON MUSEUM OF ART

West Palm Beach, Florida

January–March 2000

MARION KOOGLER MCNAY ART MUSEUM

San Antonio, Texas

April 11–June 18, 2000

JOSLYN ART MUSEUM

Omaha, Nebraska

July 10–September 24, 2000

MARSDEN HARTLEY AMERICAN MODERN

MARSDEN HARTLEY

AMERICAN MODERN

Patricia McDonnell

THE IONE AND HUDSON D. WALKER COLLECTION

FREDERICK R. WEISMAN ART MUSEUM

UNIVERSITY OF MINNESOTA

Distributed by The University of Washington Press, Seattle and London

REPRODUCTION CREDITS

COPYRIGHTS OF THE FOLLOWING PHOTOGRAPHS: Frederick R. Weisman Art Museum, p. 9 © Warren Bruland. *Ione and Hudson Walker*, p. 13 © Arnold Newman. *Marsden Hartley* (1908 or 1909), p. 77 © 1997 Bates College. Hartley's *Self-Portrait as a Draughtsman* (1908–1909), p. 77 © Allen Memorial Art Museum, Oberlin College. Hartley's *Self-Portrait* (circa 1908), p. 78 © 1997 Board of Trustees, National Gallery of Art, Washington, D.C. *Marsden Hartley* (1909), p. 78 © 1997 Bates College. *Marsden Hartley in Berlin* (1922), p. 80 © 1997 Bates College. *Marsden Hartley in front of Berlin's Reichstag* (1922), p. 81 © 1997 Bates College. *Marsden Hartley, Ezra Pound, and Fernand Léger in front of Café du Dome* (1924), p. 82 © 1997 Bates College. Marius de Zayas' *Marsden Hartley* (n.d.), p. 84, all rights reserved, The Metropolitan Museum of Art, New York. Milton Avery's *Marsden Hartley* (1943), p. 84, © Museum of Fine Arts, Boston. Frederick R. Weisman Art Museum, p. 89 © Don Wong.

Published by
Frederick R. Weisman Art Museum
University of Minnesota
333 East River Road
Minneapolis, Minnesota 55455

Designers: Feigenbaum Design Group, Minneapolis
Editor: Phil Freshman, Minneapolis
Printer: Olympic Graphics, Minneapolis
Distributor: University of Washington Press,
P.O. Box 50096, Seattle, Washington, 98145-5096

This exhibition is made possible by the generous bequest of Hudson and Ione Walker, whose gift comprises the core of the Frederick R. Weisman Art Museum's collection of works by Marsden Hartley. Additional support has been provided by the Archie D. and Bertha H. Walker Foundation. This catalogue and the exhibition tour have been made possible by support from the National Endowment for the Arts, with additional underwriting from the B. J. O. Nordfeldt Fund for American Art, Olympic Graphics, and Colorhouse, Inc.

Cover: *Abstraction with Flowers*, 1913 (detail).
Inside front cover: *Landscape No. 36*, 1908–1909 (detail).
Title-page spread, left to right: *One Portrait of One Woman*, 1916; *Landscape No. 36*, 1908–1909; Paul Strand, *Marsden Hartley*, 1928; and *Eight Bells Folly: Memorial to Hart Crane*, 1933 (details).

Note to reader: Except where noted, illustrations in the essay "Changes of Heart: Marsden Hartley's Ideas and Art" are of works in the collection of the Frederick R. Weisman Art Museum.

International Standard Book Number: 1-885116-04-7

Library of Congress Cataloging-in-Publication Data
McDonnell, Patricia, 1956–
 Marsden Hartley: American Modern: the Ione and Hudson D.
Walker Collection/Patricia McDonnell.
 p. cm.
 Exhibition itinerary, Frederick R. Weisman Art Museum, University of Minnesota, Minneapolis, Minn., June 4–August 31, 1997, and others.
 Includes bibliographical references.
 ISBN: 1-885116-04-7 (pbk.)
 1. Hartley, Marsden, 1877–1943—Exhibitions. 2. Walker, Hudson D. (Hudson Dean), 1907–1976—Art collections—Exhibitions. 3. Walker, Ione—Art collections–Exhibitions. 4. Frederick R. Weisman Art Museum—Exhibitions. I. Frederick R. Weisman Art Museum. II. Title.
N6537.H3633A4 1997
759.13—dc21 97–13221
 CIP

CONTENTS

Director's Foreword

Lyndel King

Marsden Hartley is integral to the history of the Frederick R. Weisman Art Museum, and his presence is strongly felt here—even though he never set foot in Minnesota. When the university's art museum was founded (as the Little Gallery) in 1934, Hudson Walker, grandson of Minnesota lumber magnate and art collector T. B. Walker, was a young man. He became the institution's first curator and director. When he left Minnesota to follow his passion for art as a dealer in New York City, he became a friend and patron of Hartley. He believed in the artist at a time when others did not, offering him both moral and financial support. His letters and journals are full of accounts of their meetings and detail his efforts to ensure that his friend become recognized as one of the most important American artists of the twentieth century. That

recognition did not come during Walker's lifetime, much less during Hartley's. In the last two decades, however, Hartley's status has risen and grown secure. Walker was right: Hartley *is* among the most important American artists of our century, and art historians, collectors, and museums have vindicated Walker's efforts.

Although Walker left Minnesota in the 1930s, never to return as a resident, he did not forget the state or its university. The sixty-one paintings and fifty-four works on paper—pastels, drawings, watercolors, and prints—in the Weisman Art Museum all came as a gift from Hudson Walker, from the collection he formed with his wife, Ione. We are enduringly grateful to them for providing

Frederick R. Weisman Art Museum, University of Minnesota, Minneapolis

the core of our fine holdings in American art and to their daughters, Berta, Louise, and Harriet, for their ongoing support. Hudson's sister, Louise McCannel, has likewise been a longtime friend of the museum. We also thank the Archie D. and Bertha H. Walker Foundation for its support of this exhibition.

In addition, the National Endowment for the Arts and the museum's B. J. O. Nordfeldt Fund for American Art provided financial assistance for this exhibition and catalogue as well as for the conservation of Hartley's paintings and works on paper. The Minneapolis printing companies Colorhouse, Inc., and Olympic Graphics also made donations facilitating production of the catalogue. We thank editor Phil Freshman, who always makes our publications articulate and concise. Graphic designers Dennis and Susan Feigenbaum were a joy to work with; as collectors of early-twentieth-century art, they were especially sensitive to the work and ideas of Marsden Hartley.

In producing *Marsden Hartley: American Modern*, all members of the Weisman staff, listed on page 88, functioned as the enthusiastic, experienced, efficient, and creative team they are. It is always a pleasure to acknowledge them publicly because they are outstanding in every way. In the present instance, special thanks go to Registrar Karen Duncan, Associate Registrar Shawn Spurgin, Exhibits Coordinator Mark Kramer, Curatorial Intern Jennifer Riehm, and Curatorial Assistant Mary Kalish-Johnson. Also, Director of Development Kathleen Fluegel, Director of Education Colleen Sheehy, Public Affairs Director Robert Bitzan, Museum Store Manager Kay McGuire, and Associate Administrator Gwen Sutter scrupulously attended to all pertinent details in their respective departments. I cannot imagine having completed this project without them.

Finally, special recognition must go to Curator Patricia McDonnell. She has committed her considerable expertise and much of her professional and personal time to producing a fresh, scholarly interpretation of Marsden Hartley, the artist and the man, both in the museum's galleries and in this book. Hudson Walker would be proud of her, and I am, too.

CURATOR'S ACKNOWLEDGMENTS

Patricia McDonnell

The first major retrospective of paintings by Marsden Hartley, organized by the Whitney Museum of American Art, toured the United States in 1980. I saw the exhibition in Berkeley, California. From that time forward, I have had this artist and his art on my mind. Both the strength of his paintings and the complexity of their meanings have provided me with rich sustenance.

It has been a privilege to help attract broader attention to Hartley's art and ideas through my research, publications, and exhibitions. The Weisman holds the world's largest collection of his art, and it has been a blessing for me to work with this remarkable cache. The shared commitment of the Weisman Art Museum staff to transmitting the work of this American modern to the public has been very rewarding. In her adjoining foreword,

Director Lyndel King acknowledges a number of museum staff members, all of whom played important parts in bringing this exhibition and catalogue to fruition. Karen Duncan, Mark Kramer, Kay McGuire, Jennifer Riehm, John Sonderegger, Shawn Spurgin, and especially Curatorial Assistant Mary Kalish-Johnson have my special thanks for their tireless efforts on behalf of this project.

Other Hartley scholars, colleagues, and friends have helped me to understand the artist and his time. For their insights over the years, I thank Kermit Champa, George Chauncey, Wanda Corn, Charles C. Eldredge, Paul Fussell, Thomas Gaeghtgens, Mary Gluck, Townsend Ludington, George Mosse, Gail Scott, James Steakley, Stephen Weil, Jonathan Weinberg, and Judith Zilczer. I owe a very special debt to Michael

Plante, Timothy Rodgers, and Robert Silberman for their critique of the catalogue essay as well as for their friendship and lasting support. This catalogue would not read as well as it does without the discerning contributions of editor Phil Freshman. Also, artist Robert Indiana has helped me see Hartley anew, and I thank him for sparking that refreshed awareness.

Berta Walker, as an art-world figure in her own right, directed us to Arnold Newman's photograph of her parents, Hudson and Ione Walker. They were the art patrons who supported Hartley when others did not and who donated their Hartley holdings to the then University Art Museum through a 1976 bequest. Patricia Willis, curator of Yale University's American Collection of Literature at the Beinecke Rare Book and Manuscript Library, has been immeasurably helpful over the years. She again facilitated my access to that library's rich Hartley archives for the present project. Many individuals at museums and libraries around the country accommodated our requests for information and reproduction permission. I thank the following for their timely assistance: Beth Alvarez at the University of Maryland at College Park Libraries; Barbara Chabrowe at the National Gallery of Art; George Platt Lynes II; Genetta McLean at the Bates College Museum of Art; Ruth Nyblade at the Allen Memorial Art Museum, Oberlin College; Arthur Olivas at the Museum of New Mexico; Mary L. Sluskonis at the Museum of Fine Arts, Boston; and Judy Throm at the Archives of American Art, Smithsonian Institution.

The museum conserved and reframed many of the works featured in this exhibition. Painting conservator James Horn, sculpture conservator Kristen Cheronis, and paper conservator Elizabeth Bouschor have our deep gratitude for the radical transformations their labors produced. William Adair of Gold Leaf Studios, Washington, D.C., and Minneapolis framer Patti Landres gave many paintings new life by crafting historically appropriate frames. Robert Fogt helped us present these works of art by photographing many of them anew for reproduction in this publication.

Finally, Lyndel King has my immense thanks for standing behind this project, and me, with supplies of encouragement, advice, heart, and with a shared passion for the art of Marsden Hartley.

Arnold Newman, Ione and Hudson Walker, *1964.*

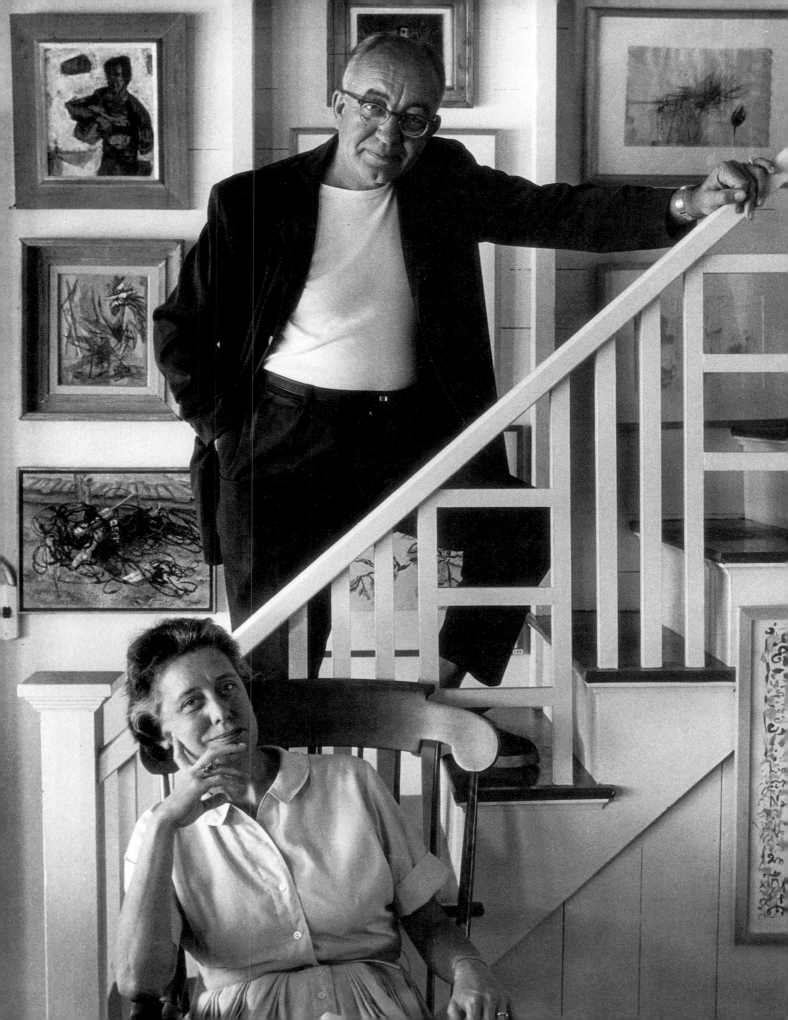

CHANGES OF HEART: MARSDEN HARTLEY'S IDEAS AND ART

Patricia McDonnell

I am convinced," wrote the American painter Marsden Hartley in 1912, "that the intuition is the only vehicle for art expression and it is on this basis that I am proceeding."[1] A short seven years later, the following words came from his pen: "Real art comes from the brain, as we know, not from the soul."[2] Clearly, these statements are unequivocally opposed. How should enthusiasts of Hartley's art understand this radical about-face?

Early in his career, Hartley professed strong allegiance to a subjective course. Starting in about 1918, however, he disavowed such an approach. As he later explained, "I no longer believe in the imagination. I rose one certain day—and the whole thing had become changed. I had changed old clothes for new ones, and I couldn't bear the sight of the old garments." He voiced his objec-

tions so strongly that it is almost as if Hartley believed he might contract a rash from the "old garments." "I can hardly bear the sound of the words 'expressionism,' 'emotionalism,' 'personality,' and such," he declared.[3]

To understand Hartley and his art, one needs to confront the glaring discrepancy and momentous transition reflected in his words. Coming to terms with *why* Hartley painted as he did will also help viewers comprehend *what* and *how* he painted. In short, we need to take into account the thought behind his canvases, even, and especially, the dramatic shifts in these thoughts. Attempts to appreciate an artist's ideas fully must also include an eye and ear to the events of his or her time, for ideas and art of course do not incubate in a vacuum. Offered here, then, is a condensed look at

FIGURE 1 • AUTUMN, 1908. Oil on canvas.

▲ FIGURE 2 • LANDSCAPE, VENCE, 1925–1926. Oil on canvas.

▶ FIGURE 3 • CHINESE SEA HORSE, 1941–1942. Oil on canvas.

Hartley's fundamental aesthetic positions aimed at fostering a better understanding of this significant American modernist. In telling the story of Hartley's sweeping changes of heart, I will sketch in the personal and cultural circumstances behind them and, in doing so, examine how Hartley presented himself.

The grouchy rejection of imagination quoted above comes from "Art—and the Personal Life," an essay Hartley wrote for the June 1928 issue of the journal *Creative Art*. The essay has accumulated considerable importance over the years, in part because of its inclusion in many major anthologies of writings documenting the history of modern art. Two such books, Herschel Chipp's *Theories of Modern Art* and Barbara Rose's *Readings in American Art, 1900–1975*, collections of artists' writings that were both published in 1968, have had particular impact. They quickly became curriculum staples in introductory classes, enjoyed multiple reprintings, and helped form the thinking of many thousands of students and scholars of modern art.[4] Interestingly, both Chipp and Rose, faced with Hartley's prodigious output of essays, poems, and reviews, chose to excerpt from just one piece of his writing: "Art—and the Personal Life."[5]

On the positive side, the inclusion of Hartley's voice in these influential volumes has kept him on the honor roll of modern artists whose contributions are deemed important. On the other hand, though, he has become best known to several generations of readers through a text that, as I hope to make clear, provides an inaccurate picture of his most firmly held convictions about art and life—personal or otherwise.

Hartley's life as an artist began under the sway of the American writers Ralph Waldo Emerson, Walt Whitman, and William James. Early in his career two great provocateurs, the author Gertrude Stein (1874–1946) and the photographer-editor-art dealer Alfred Stieglitz (1864–1946), befriended him. In addition, he admired the French philosopher Henri Bergson and read spiritualist texts. These sources and more fed Hartley's commitment to the life of the soul over the life of the mind. "Gertrude Stein is right," he wrote to Stieglitz in 1913, "when she says that true art cannot explain itself."[6] At the height of his quest for

the intuitive, he made claims tinged with language gleaned from his spiritualist readings. He said of his paintings, for example, that "they are the expression of spiritual states of being."[7] And to the German expressionist painter Franz Marc he explained that "I am by nature a visionary."[8]

The conditions that fostered this early aesthetic position and passion for an intuitive approach dissolved, for Hartley and other artists, as a consequence of World War I. Having lived and worked in Paris and Berlin since 1912, Hartley returned in December 1915 to a homeland that had already reacted strongly to the brutalities of the war and would soon be drawn into it. Beginning in 1917 and 1918, he came to grips with the schism between his former inclinations and the very changed tenor of the times. He adopted a milder, restrained approach and asked for reliance upon "intellect," as he called it. Hartley refined these ideas and new direction in articles and essays he wrote from 1918 to 1921. He embraced rationalism with the vengeance of the newly converted. "Intellectual clarity," he instructs in the famous 1928 essay, where his expression of this mode of thought is at its height, "is better and more entertaining than imaginative wisdom or emotional richness."[9]

Hartley's conversion—if we can call it that—resulted directly from profound changes wrought by the Great War and, I believe, would not have been likely to occur under different circumstances. Indeed, he had abundant company, for there was scarcely an artist who did not undergo serious change in reaction to the new political and cultural realities ushered in by the war. Max Beckmann, Thomas Hart Benton, Georges Braque, Wassily Kandinsky, Alfred H. Maurer, and Pablo Picasso were among a legion of those who dramatically shifted their artistic gears and inclinations in the late 1910s and 1920s.

In the late 1930s and early 1940s, as Hartley neared the end of his life, he reconciled himself to his initial beliefs about the important contribution of an artist's subjective side to his or her art-making. His late paintings from Maine, like his early works, exude an emotional intensity. All these canvases—his moody landscapes, his sturdy and archaicized fishermen, and his elegiac series of portraits—convey this artist's expressive and subjective core. Their potent expressionism is a large factor in the admiration these important late works of art have garnered over the years. This final shift *back* to where he started supports the idea that Hartley altered his course and artistic agenda in the decade or so following World War I as a sink-or-swim reaction. In other words, because the cultural climate changed so profoundly with the war, any ambitious artist who hoped to remain part of the current needed to reimagine himself or herself.

Interwoven within the various artistic, philosophical, and cultural forces that shaped him were subtle, and sometimes not so subtle, notions of sexuality. For Hartley, a homosexual, this was

FIGURE 4 • FINNISH-YANKEE SAUNA, 1938–1939. Oil on academy board.

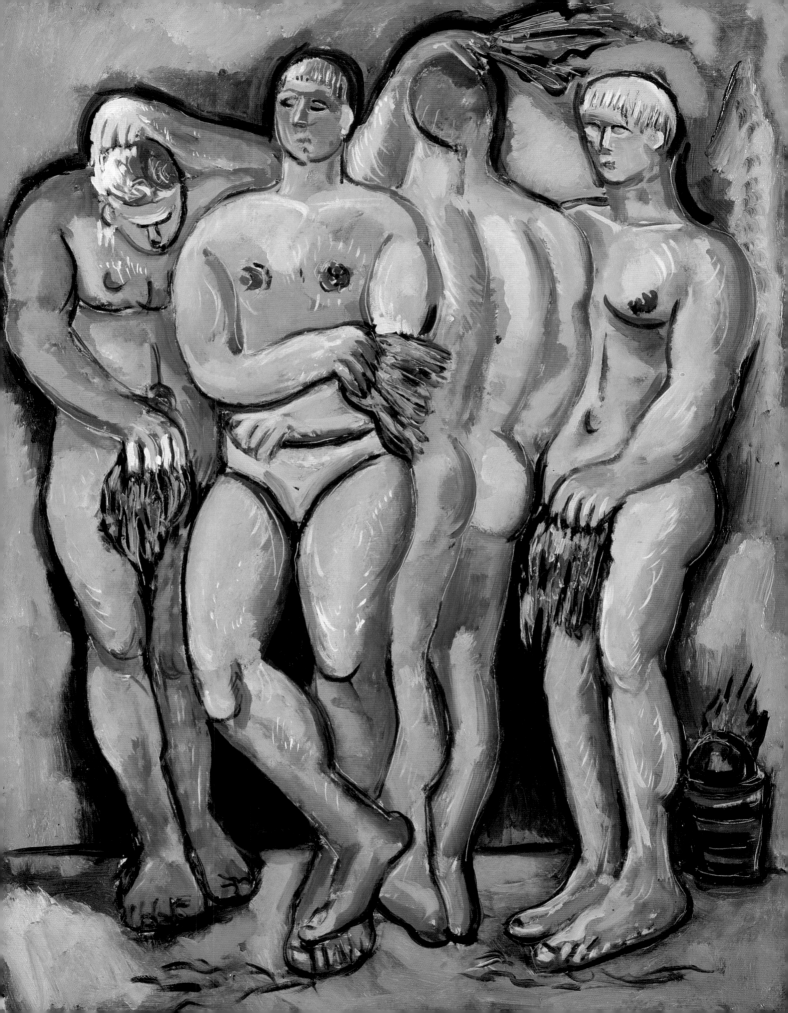

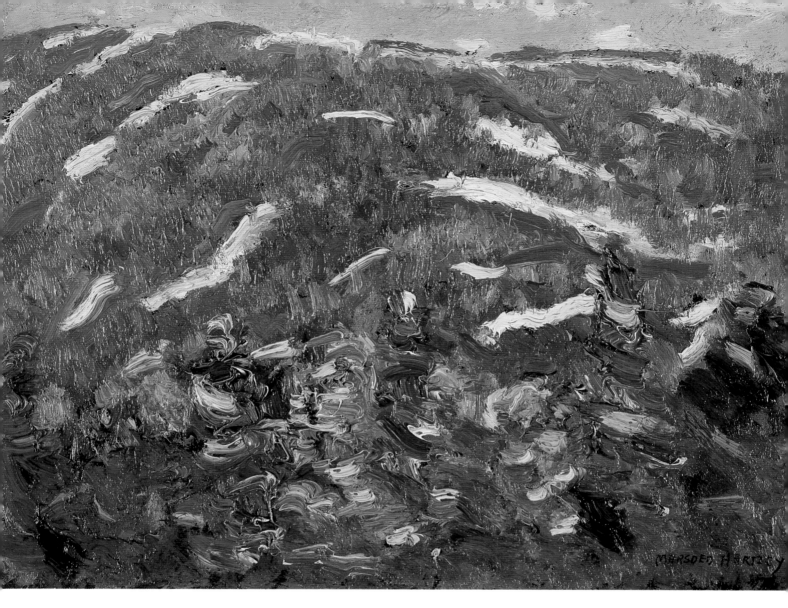

FIGURE 5 • SONGS OF WINTER, circa 1908. Oil on academy board.

"[My paintings] are the product of wild wander and madness for roaming—little visions

of the great intangible." (1908)

particularly problematic. As a gay man in an era when public admission of that side of oneself meant social and artistic ruin—to say nothing of criminal prosecution—he routinely masqueraded as something he was not. The procedures of concealment remained overwhelming concerns throughout his life. In company with generations of homosexual men who lived before the advent of the gay-rights movement that emerged in the second half of the twentieth century, he needed to heed the French author Marcel Proust's advice to his compatriot André Gide: "You can tell anything [about homosexual experience] . . . but on the condition that you never say: I."[10] Hartley constantly sought a subject matter that, on the one hand, would represent his authentic inner self—a core goal for modernism and modern artists. On the other hand, his art could reveal only that part of him available for public view and in step with conventional social mores. Hence the alignment between his art and his life was never a direct coefficient for Hartley. As a gay man, he had to thwart self-expression severely.

Hartley moved from style to style and from subject to subject. This incessant shifting in his art, I believe, relates in part to his homosexuality. The repeated changes in his artistic production as well as his perpetual wanderings arose, at least in some measure, from his need to keep a forbidden secret. The insecurity of leading a closeted existence helped fuel his need to recreate himself, and, at certain intervals, to remake his art. Also, living in the closet appears to have made it easier

for him to present himself, in both personal and artistic terms, in a variety of ways at different moments without acknowledging his philosophical leaps and twists. I believe that Hartley was sincere in his assertions and that the significant shifts in his thinking and art were not impulsive. But his ability to make such grave changes, and to make them so swiftly, does appear to have had some basic link to the role-playing he performed as a homosexual man. As a consequence, admirers and students of Hartley must be cautiously critical when thinking about how he presented himself and why he cast himself as he did at any given moment.

In charting Marsden Hartley's path from intuition to intellect and back again, the place to start is where the artist himself began and ended: the State of Maine. Born to English immigrants in the town of Lewiston in 1877, Hartley had a troubled childhood. His mother died when he was eight. Four years later, his father married Martha Marsden and moved with his new bride to Ohio, leaving the boy with an older sister in Auburn, Maine. He joined the family in Cleveland in 1893, beginning art lessons and then art school there. These early dislocations set the stage for the rootless, peripatetic pattern of the artist's life. He even changed his first name—the supreme shift of identity, perhaps—from Edmund to Marsden in 1906, when he was twenty-nine.

He first attracted attention as an artist in 1909, when Alfred Stieglitz responded favorably to his early renderings of the Maine mountains. Stieglitz

arranged Hartley's first one-person exhibition featuring these paintings that May in his rambunctious New York gallery—named 291 after its location at 291 Fifth Avenue—which, from 1905 to 1917, promoted the then-radical work of European and American modernists. This show and Hartley's subsequent long-standing affiliation with Stieglitz and his avant-garde circle of leading American artists, writers, and cultural critics drew Hartley into the art-world limelight.

The Weisman Art Museum is fortunate to have many fine examples from this episode in Hartley's career. *Summer* (cat. 2, fig. 7), *Autumn* (cat. 4, fig. 1; p. 15), *Songs of Winter* (cat. 6, fig. 5; p. 20), and *Mountainside* (cat. 7, fig. 8; p. 24), all date from 1908 and 1909 and represent the artist's daring beginnings. As he expressed it, his project in these works was to render "the God-spirit in the mountains."[11] This cycle of Maine paintings is clearly informed by the work of American impressionists such as Thomas Dewey, Ernest Lawson, Edward

Redfield, and John Twachtman. Like these artists, Hartley worked to master the pictorial vocabulary that had originated in France in the 1860s and become popular in America near the end of the century. Unlike the French impressionist artists, however, his goal was not simply to manipulate the formal properties of paint on canvas as a joyous end in itself. Instead, he saw gestural impressionist paint-handling as an ideal vehicle for expressing his emotional, even spiritual, experience in the landscape.[12]

Maine Snowstorm (1908) (cat. 1, fig. 6) demonstrates Hartley at the height of his power in these early years. In this work, innovative technique underscores symbolic content. He believed his early landscapes, like *Maine Snowstorm*, spoke "of [the] supremacy of mighty things—things that ... are conscious only of the great energy in them over which they have no direction—[.]"[13] Pictorially, the canvas is a blur of rapid strokes of tonal color. Keeping color within a basic monochromatic

range of pale blues and whites and maintaining active, forceful brushwork across the entire image, he creates a pervasive and thereby unifying surface effect. Stressing the physicality of every inch of the picture plane through the active touch of his brush, he signals his belief in the omnipresent forces resident

▲ FIGURE 6 • MAINE SNOWSTORM, 1908. Oil on canvas.

◄ FIGURE 7 • SUMMER, 1908. Oil on academy board.

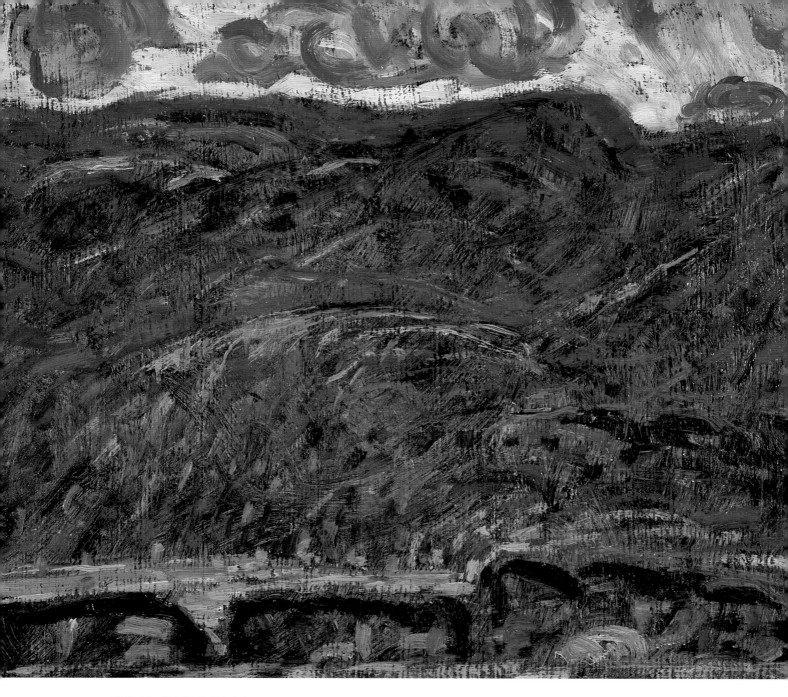

▲ FIGURE 8 • MOUNTAINSIDE, 1909. Oil on academy board.

▶ FIGURE 9 • LANDSCAPE NO. 36, 1908–1909. Oil on canvas.

in nature. It is Hartley's invention visually to symbolize "the pulse & secret of all that is."[14] Effusive, gestural paint-handling, then, is one stylistic option for him when working to pour his subjective self onto his canvases.

The source for this outlook is to be found in American transcendentalism. Ralph Waldo Emerson (1803–1882), a leading spokesman for a group of philosopher-authors in mid-nineteenth-century New England, had been a favorite of Hartley for years by the time he produced his early Maine-mountain paintings. Later he acknowledged that his first reading of Emerson's two-part collection, *Essays* (1841, 1844), in about 1898 was "to provide the religious element in my experience."[15]

A literary and philosophical movement associated with Emerson as well as with Bronson Alcott, William Ellery Channing, Margaret Fuller, Henry David Thoreau, and Walt Whitman, transcendentalism sought to break the strong grip that Puritanism had long had on American life and thought. Transcendentalists sought a shift from what they saw as a suffocating reliance on religious doctrine toward a greater freedom for individual religious expression. The pragmatist philosopher John Dewey later charac-

terized Emerson as having been "jealous for spiritual democracy."[16] Rather than privilege the routines of the church, its dogma, and scripture, as Puritanism did, transcendentalists placed a higher value on the individual's own heartfelt spirituality. Further, they saw the individual's greatest opportunity for access to divine spirit in the verdant riches of nature. Emerson often capitalized the noun, Nature, to communicate the importance he ascribed to it. "The noblest ministry of nature," claimed Emerson, "is to stand as the apparition of God. It is the organ through which the universal spirit speaks to the individual, and strives to lead the individual to it."[17]

Two more tenets of transcendentalism are pertinent to Hartley. The first is transcendentalism's belief in the omnipresent "Over-Soul" or "Aboriginal Power," as Emerson called it, in

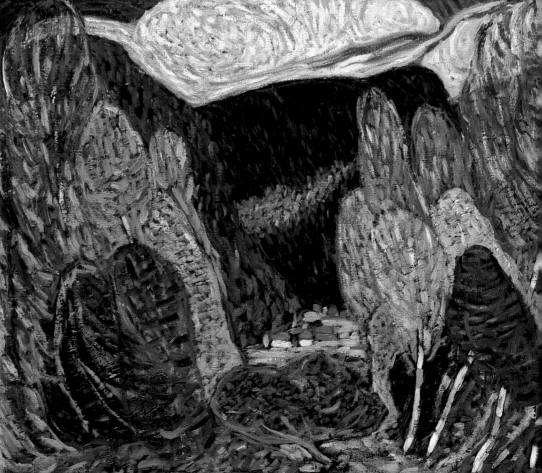

nature. An animate life force permeated all nature and all life and rendered distinct parts indivisible from the whole. Emerson made this concept clear, writing, "Nature with all her craft . . . from the beginning to the end of the universe, she has but one stuff. . . . Compound it how she will, star, sand, fire, water, tree, man, it is still one stuff, and betrays the same properties."[18] Having "but one stuff," the sensitive seer can unlock the power of this animate force through careful observation of nature's unique elements. "A leaf, a drop, a crystal, a moment of time, is related to the whole, and partakes of the perfection of the whole. Each particle is a microcosm," Emerson again clarifies, "and faithfully renders the likeness of the world."[19]

The second important point to bring to light regarding transcendentalism and its impact on Hartley concerns that movement's secular spiritualism. The initial aim of transcendentalism, recall, was to offer the individual greater control over the means of religious expression. This goal makes its characteristic emphasis on spirituality understandable. Many transcendentalists, however, built upon this emphasis. They called for a self-directed, inward approach to an awakening of spirit. Emerson's descriptions of revelations of nature's ineffable power often border on the mystical because he represents these experiences as rapturous and all-consuming.

Hartley internalized this worldview and, over the course of his career, discovered a whole variety of ways to give it pictorial expression. Part of his enduring contribution to the art of his time is his insistence on the values of American transcendentalism and his translation of them into a vanguard artistic idiom. Marsden Hartley was not alone in this. He found like-minded company within the Stieglitz circle, for this cadre of progressive artists were, in the words of the art historian Matthew Baigell, also "resolutely, almost belligerently, Emersonian."[20]

His introduction to the Stieglitz group and increasing comfort within it encouraged Hartley to step up the daring of his already radical painting. Through the exhibitions Stieglitz organized, Hartley caught his first glimpse of modern European art. Works by Paul Cézanne, Henri Matisse, and Auguste Rodin were part of the fare he absorbed at 291. In turn, he reinvested the visual discoveries he made there into his own repertoire. *Landscape No. 36* (1908–1909) (cat. 3, fig. 9; p. 25), *Waterfall* (1910) (cat. 10), *Abstraction* (1911) (cat. 11, fig. 10), and *Still Life: Fruit* (1911) (cat. 12, fig. 11; p. 28)—all demonstrate Hartley's eagerness to find his way among the moderns and establish himself as an artistic presence to be reckoned with. The brighter hues in his mountain landscapes of 1908—before his involvement with Stieglitz—demonstrate that he was already aware of avant-garde tendencies. Hartley's color explosion in 1909 through 1911—witnessed in the paintings just noted—shows his absorption of Matisse's intense colors, Cézanne's ordered compositions, and the progressive work of other Stieglitz-sponsored artists such as Arthur Dove and John Marin.

FIGURE 10 • ABSTRACTION, 1911. Oil on paper on cardboard.

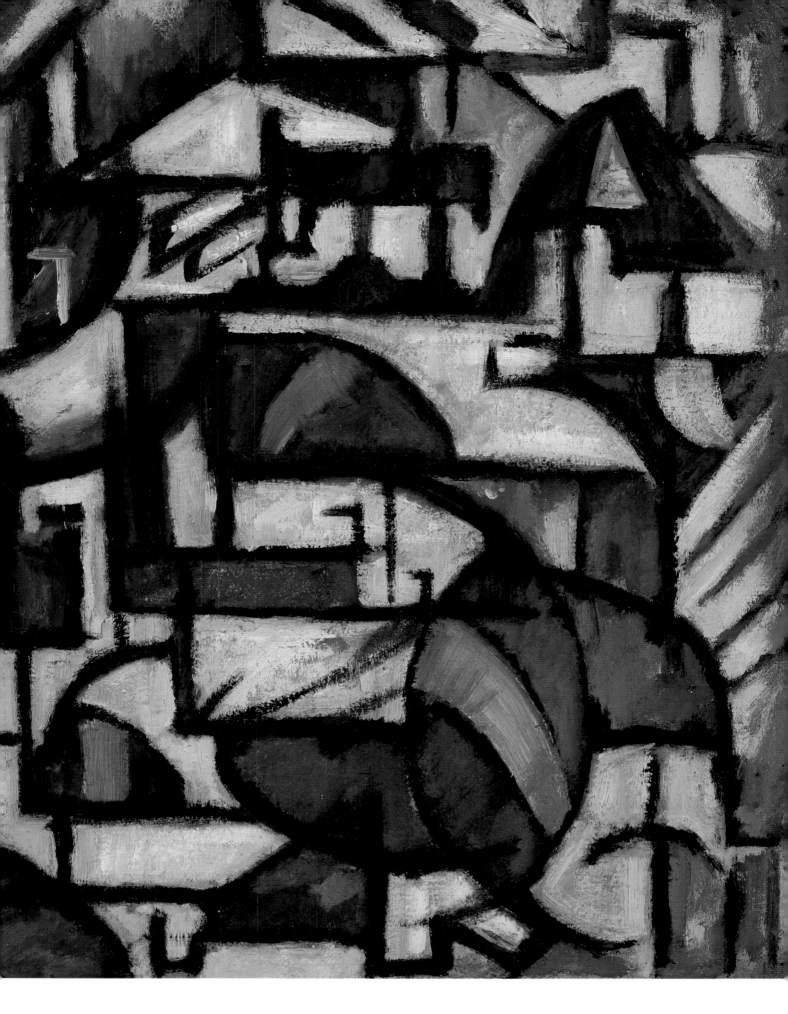

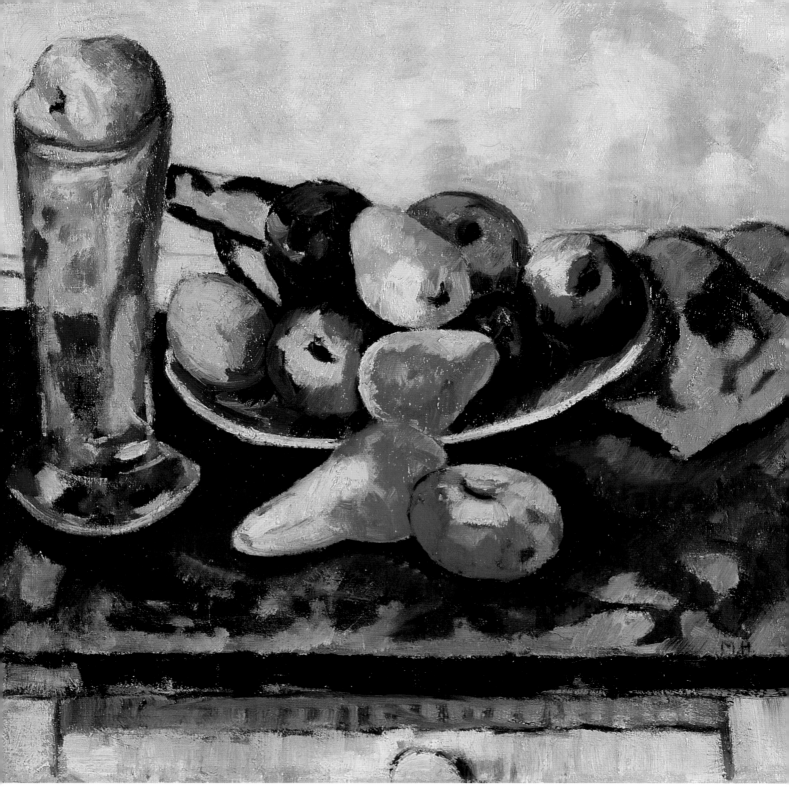

FIGURE 11 • STILL LIFE: FRUIT, 1911. Oil on canvas.

His strong stylistic changes during these years, however, did not substantially alter the philosophical aims of his art. His deepening pictorial radicalism aside, Hartley remained committed to a willfully subjective approach. He explained to his niece Norma Berger in 1910 that "I work almost wholly from the imagination."[21] A year later, he wrote Stieglitz several sentences that might stand for his life's agenda:

> A lifetime of breathless endeavor to be the thing and do the thing of his being— So easy to travel along with claques and crowds, voicing vociferously the great discoveries of each— How ineffably difficult, voicing the soul of one man— alone to himself and— then to whoever else hears— . . . So do I live and work—[.]"[22]

The task Hartley set for himself, one requiring strong personal resolve and independence, was to voice his soul.

In 1912 Hartley achieved a long-harbored desire, heading off for the expatriate experience in Europe. He would remain abroad for three and one half years. His first destination was Paris. In this exciting new setting—and, subsequently, in Berlin—Hartley remained steadfastly loyal to his transcendentalist heritage and celebration of intuition. Indeed, as he came to know other European modernists and carefully study their work, he saw the art that he most admired through the lens of his own inclinations. Cézanne and Picasso were his special favorites when he arrived in Paris. From Hartley's writing about them and his appreciation of their accomplishments, one might think they had developed as chums and compatriots of Emerson, Thoreau, and Whitman.

"Cézanne," Hartley believed in 1912, "had an eye which 'saw' a new depth—[.]" Elsewhere he wrote, "When he painted fruits + flowers + people + trees— [he] left upon them a wonderful sense of the cosmos."[23] For Hartley, Cézanne's breakthrough did not center on his formal innovations per se but on his intuitive expressiveness, something Hartley then called "vision." This emphasis was Hartley's own: "Vision" was what he wanted to register in his work. In an essay begun about this time yet not published until 1921, he wrote that Cézanne "felt this 'palpitancy,' the breathing of all things. . . . He felt this 'movement' in and about things, and this it is that gives his pictures that sensitive life quality. . . . They are not cold studies of inanimate things, they are pulsing realizations of living substances."[24]

Given this obvious reverence, it is not surprising that Hartley began a series of still-life paintings in 1912 that pay clear homage to his French predecessor. *Still Life: Fruit* (fig. 11) makes clear that Hartley had already been preoccupied with this French master in 1911, before his journey abroad. That painting, along with *Still Life* (1912) (cat. 13, fig. 12; p. 31), replicates many of Cézanne's staple characteristics—his tilted tabletop, his selection of a few simple objects, his muted palette, and his complex pictorial interplay between two- and three-dimensional forces. Hartley, however, achieves the decorative stress in his 1912 image

not by fracturing his brushstroke, as Cézanne did, but rather by creating a pervasive linear system that both defines the still-life objects and establishes a strong decorative pressure throughout the image. This last feature, a pulsating linear grid across the picture surface, is cubist in origin and reflects Hartley's exposure to other avant-garde circles early in his Parisian stay.

Hartley was able to study works by Cézanne and Picasso firsthand in the home of Gertrude Stein. With her brother, Leo, Gertrude collected these artists' paintings and displayed them in her famous apartment at 27 rue de Fleurus, the gathering place for progressive writers and artists of many nationalities and persuasions. Stein warmed to Hartley and his art. She flattered him by saying she found him to be "one of the important people." She also wrote encouragingly to Stieglitz that "Hartley has really done it," going on to explain that "He has done what in Kandinsky is only a direction. . . . Each canvas is a thing in itself and contained within itself and the accomplishment of it is quite xtraordinarily [sic] complete."[25] As the ultimate compliment, perhaps, she purchased several drawings by Hartley and hung them in her home alongside a Cézanne, a Manet, and a Renoir.[26]

Hartley's contact with Stein came at a fortuitous moment, for she helped him, unwittingly perhaps, to make critical advances in his art. He seems to have understood this, too, because he explained to Stieglitz that "the best asset I have had all along over here is Gertrude Stein."[27] Her challenging intellect stimulated him, and her enthusiasm for his art

bolstered his confidence. More important, Hartley came to understand that their artistic enterprises shared fundamental concerns.

Stein had very recently taken a new stride in her writing when she and Hartley met. She had broken her language loose from linear narrative and tight description of events and appearances, launching into a freely abstract and idiosyncratic speech form. She had moved from literal description to concrete poetry in an effort to evoke the core of the given subject more accurately than standard prose allowed. As the literary historian and critic Wendy Steiner explains, "What Stein intended to achieve by the reification of her words and sentences was not to do away with a referential subject, to obliterate the sign-function of language, but to create a text which would be mimetically adequate to her subject."[28] The author herself suggested that her project was to "understand the meaning of being" in the people and things she wrote about. She wanted to render their "bottom nature," as she called it, and to do so with language that itself captured their movement and energy without any mediating gap.[29] Like William Faulkner, James Joyce, and other literary contemporaries, Stein relied on the reader's intuitive grasp of experiences that she rendered with an abstracting immediacy. Her ability to compose this kind of writing effectively involved, as Hartley described it to her, a "going into new places of consciousness."[30]

FIGURE 12 • STILL LIFE, 1912. Oil on composition board.

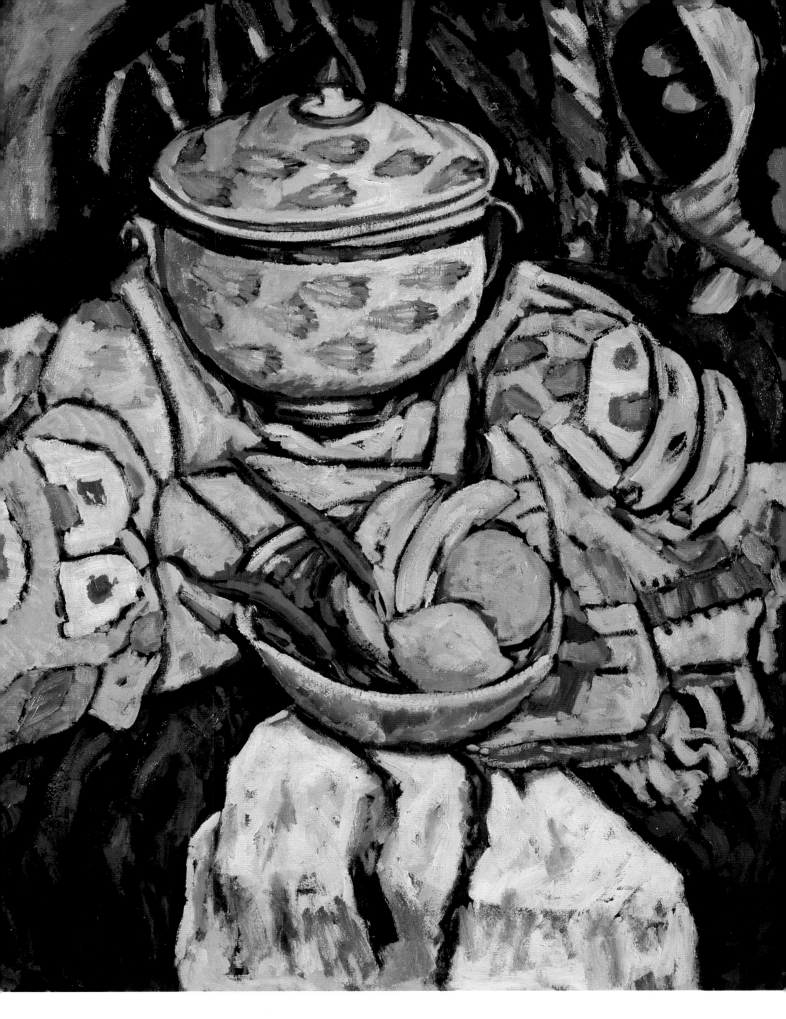

An important source propelling this literary advance was Stein's interest in the American philosopher William James (1842–1911). She had studied psychology with the Harvard professor in 1895 while attending Radcliffe College, and she remained in contact with him from Paris. Their connection is significant, because Stein and Hartley began discussing James' writings soon after meeting. She lent the artist James' *The Varieties of Religious Experience*, and Hartley later dated the starting point of their closer relationship to the moment "when I asked to borrow her copy of this book."[31] In 1913 he confided that he came to "my newest means of expression . . . by way of James[.]"[32] In fact, the book revealed the broad outlines of James' ideas to Hartley at this critical point in his career.

Brother of the novelist Henry James, William James was a pioneer in the field of psychology at Harvard. He wrote *The Principles of Psychology* in 1890, a decade before Sigmund Freud began published circulation of his ideas. James is today better known for his later contributions to philosophy through such books as *The Varieties of Religious Experience* (1902), *Pragmatism* (1907), and *Essays in Radical Empiricism* (1912).

In his insistence on the primacy of the individual, James was very much a man of his times. The conceptual resonances between his ideas and those of Henri Bergson, John Dewey, Friedrich Nietzsche, and George Santayana are strong. Keeping Hartley's emerging aesthetics in mind, it is critical to note that James also followed and developed precepts advanced by Ralph Waldo Emerson, bringing concepts basic to transcendentalism into philosophy proper. Reading James, Hartley would have felt the thrill of recognition and heard many thoughts he had already internalized through Emerson.

Like Emerson, James argued for a greater trust in the individual's subjective perceptions than either an overbearing Puritan doctrine or an overwhelming scientific materialism in their time allowed. Inner intuitions, not strident mental concepts or external material facts, needed to be heeded first. Bucking the legacy of eighteenth-century Enlightenment positivism, which holds that we can only ever *know* that which we can physically sense and see and rationally posit, James worked for the inclusion of a greater realm of human experience within the pool of options open to epistemological consideration. "The deeper features of reality are found only in perceptual experience," James asserted. "Introspective observation," and not attention to the physical, material realm alone, "is what we have to rely on first and foremost and always."[33]

His undertaking in *The Varieties of Religious Experience* was to open up the philosophical dialogue and pave the way for an inclusion of subjective experience. "It is vain for rationalism to grumble about this," he argued. "Mystical experiences are as direct perceptions of fact for those

FIGURE 13 • ABSTRACTION WITH FLOWERS, 1913. Oil on canvas.

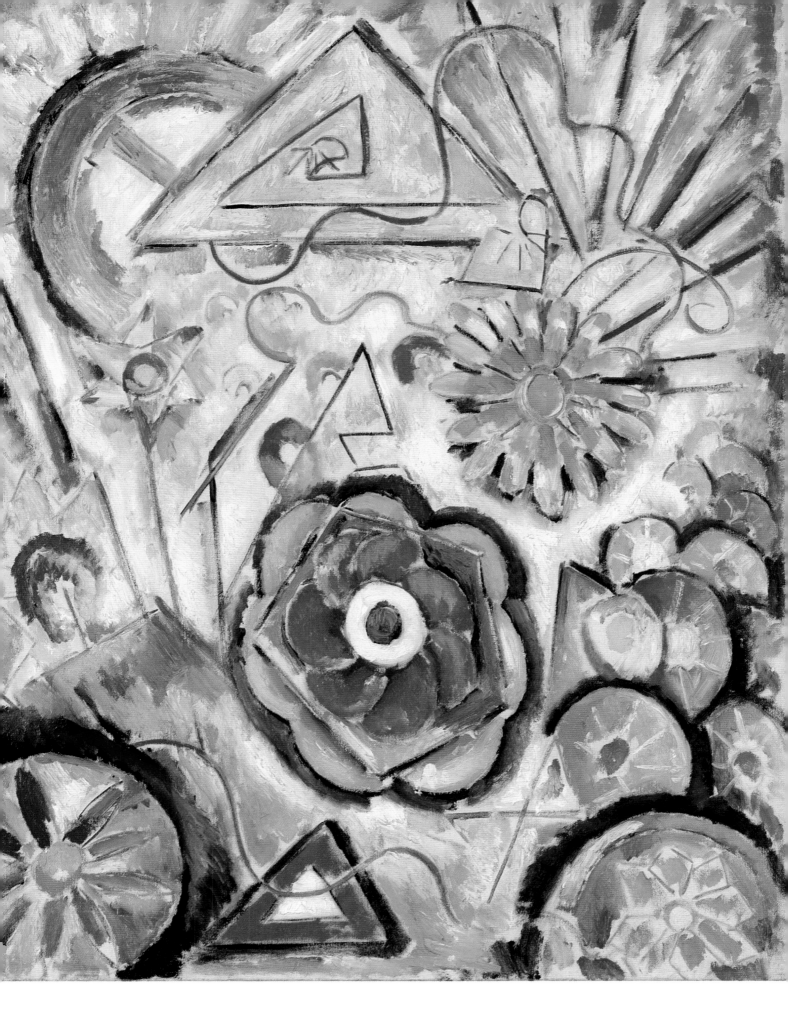

who have them as any sensations ever were for us." Further, "the existence of mystical states absolutely overthrows the pretension of non-mystical states to be the sole and ultimate dictators of what we may believe."[34]

James predicates this insistence on personal experiences—mystical and otherwise—on his corollary belief that one cannot cleanly separate parts of human experience. For the philosopher, physical sensation is one with subjective, intuitive perception because the nature of reality is itself continuous and whole. (Here again we see James' debt to Emersonian transcendentalism.) We come to an understanding of reality through individual and unmediated (i.e., subjective) experience, but this experience also centers on a seamless relation or rapport with fixed objects and our perceptions of them. "Personal experience" is the connective tissue for James. "Experience has no such inner duplicity," he believed, and "we have every right to speak of it as subjective and objective at once."[35] Thus "pure experience" and "perceptual experience" came to define, for him, the "one primal stuff in the world, a stuff of which everything is composed."[36]

Hartley's interest in James' writing, sparked in 1912, helped the painter redirect his thinking and art and later led him to major accomplishment. Stein's appropriation of these ideas to fuel her literary experiments at the same time was certainly another significant factor in Hartley's burst of confidence and maturing art from 1912 through 1915. Hartley biographer Townsend Ludington similarly

feels that "James' study was the centerpiece in Hartley's coming to understand what he felt" in his years abroad.[37]

At least initially, *The Varieties of Religious Experience* led Hartley to delve into spiritualist writings.[38] The inventory of the library of the sculptor Arnold Rönnebeck (1885–1947), who was Hartley's friend in Paris and Berlin, suggests that he would have been a handy source for the loan of such writings and for conversation about them.[39] Hartley wrote Stieglitz that he had been sampling such authors as Jacob Boehme, Meister Eckhart, Johannes Tauler, and Jan van Roeysbroeck and such texts as the Hindu *Bhagavadgita* and Richard Bucke's *Cosmic Consciousness* (1901).[40] As a somewhat predictable consequence of this constellation of influences, Hartley pursued a greater subjectivity—indeed, he began to paint abstractions. He acknowledged that "I have felt this great necessity in painting of leaving objective things— and after a summer of still-life [sic] I found myself going into the subjective[.]"[41] He called the series of paintings that resulted "subliminal or cosmic cubism." *Abstraction with Flowers* (1913) (cat. 14, fig. 13; p. 33) is an example of a work that Hartley considered "closer to true vision— true art intuition."[42]

Writing his autobiography, *Somehow a Past*, in the late 1930s, Hartley recalled his method for these paintings.

> *I had stopped doing beans and apples— and thought I would just take some canvases and begin more or less in the style of automatic writing and let my hand be*

guided as it were— and I made lines and curves— stars and various images and colored them lightly so that the whole effect came to have an inspirational and transcendent quality. . . . [T]hey began to be sort of portraits of moments—[.][43]

Stein's concrete poetry and "automatic writing," James' arguments for the validity of subjective mystical experiences, and Emerson's celebration of the primacy of self—all stand clearly behind Hartley's new canvases and thought. Reading Hartley's letters from the period, one quickly discerns the impact of these mentors.

Hartley repaid his debt to his intellectual benefactors in the moving paintings he produced in Berlin, where he resettled in 1913. There he developed and deepened his conceptual objectives, and he resolved the pictorial challenges he set for himself. Most art historians agree that the paintings Hartley produced in the German capital are among the finest of his career. In them, he was finally able to sort through a welter of impulses to determine what he wanted

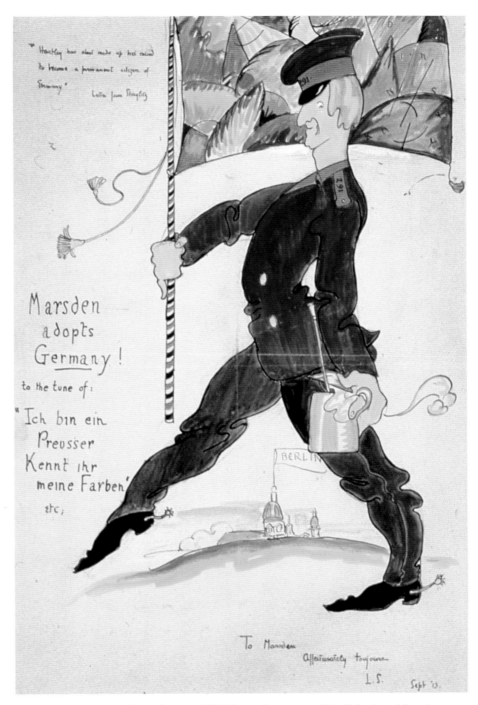

Lee Simonson, Marsden Adopts Germany, 1913. Watercolor on paper, Yale Collection of American Literature, Beinecke Rare Book and Manuscript Library, Yale University.

to do and invent a creative visual and symbolic means to express it.

The full story of Hartley's two and one-half years in Germany—beyond the scope of this essay—has been explored in a recent exhibition and accompanying book.[44] Nonetheless, a brief look at this period is essential to an understanding of the artist's ultimate character and achievement. Hartley decided to move to Berlin after visiting the city early in 1913 at the invitation of German friends he had made in Paris. His passion for the place was immediate. He reported that he came alive there and found it "without question the finest modern city in Europe."[45] Berlin, the Prussian capital, had become the capital of the newly unified federated principalities of Germany at the close of the Franco-Prussian War in 1871. There, as in most other major metropolitan cities early in the century, industrialization roared and new factories and urban entertainments drew throngs of new residents. Increasing technological advances also brought electrification, subway and telephone systems, and extensive construction. Cabaret life, silent movies, amusement parks, manufactured consumer goods, and more materialized in Berlin. Hartley was immensely stimulat-

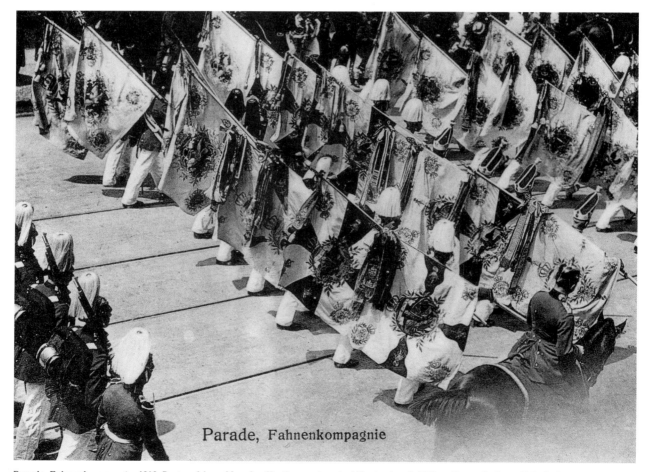

Parade, Fahnenkompagnie

Parade, Fahnenkompagnie, *1913. Postcard from Marsden Hartley, postmarked September 5, 1913, to Gertrude Stein, Yale Collection of American Literature, Beinecke Rare Book and Manuscript Library, Yale University.*

ed by this surging metropolis. He loved its "move-
ment and energy," which "leans always a little
over the edge of the future[.]"[46]

Berlin also had the attraction of being the
imperial capital. The power-bent Wilhelm II made
certain that the authority of his court was every-
where present in Berlin. The military guard shut-
tled regularly about the city, escorting dignitaries
from court to palace or stepping high to their own
drills. Hartley loved these men in uniform. "The
military life adds so much in the way of a sense of
perpetual gaiety here in Berlin. It gives the
stranger like myself the feeling that some great
festival is being celebrated always."[47]

Enamored of "the life color of Berlin" as he
was, Hartley began to paint it.[48] It was the city's
"life spectacle" and his experience of it that he
sought to capture. His initial Berlin paintings are
montages of brilliant colors, numbers, military
insignia, cavalry parades, and mystic motifs—
Hartley's own pictorial reverie to the manly athleti-
cism and dynamism he so enjoyed there[49] (fig. 15;
p. 41). He continued his project to produce paint-
ings that were abstract "portraits of moments."
They were, as he wrote in a statement accompany-
ing an exhibition of his work at Stieglitz's 291 in
1914, a replication of "a new fire of affection for the
living essence everywhere," and he hoped with
them "to express a purely personal approach."[50]

On one level, Hartley's accomplishment was
to find a visual complement to the thoughts he had
internalized amid his immersion in William
James. In his correspondence during this period,

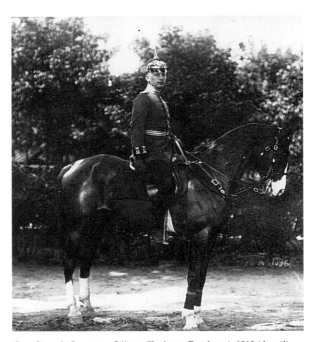

Otto Streich, *Prussian Officer (Karl von Freyburg), 1913 (detail).*
Photograph, Yale Collection of American Literature, Beinecke
Rare Book and Manuscript Library, Yale University.

Hartley repeatedly voiced his goals in language
that has a distinctly Jamesian ring. "Everything I
do," he wrote Stieglitz, "is attached at once +
directly to personal experiences— It is dictated by
life itself—[.]" Some months earlier, he had put it
this way: "I have simply one object in life and this
is to attend wholly to the dictation of the ideas
that come to me through inner personal experi-
ence—[.]" The primacy of "personal experience"—
James' "one and only stuff of the world"—is what
Hartley now represented with the pictorial rhetoric
of modernism's most radical edge.

Gaiety about the spectacle of Wilhelmine
Berlin went out of Hartley and his art with the
onset of the Great War in August 1914. In October
one of his dear friends, Karl von Freyburg—a
German lieutenant who was a cousin of Arnold

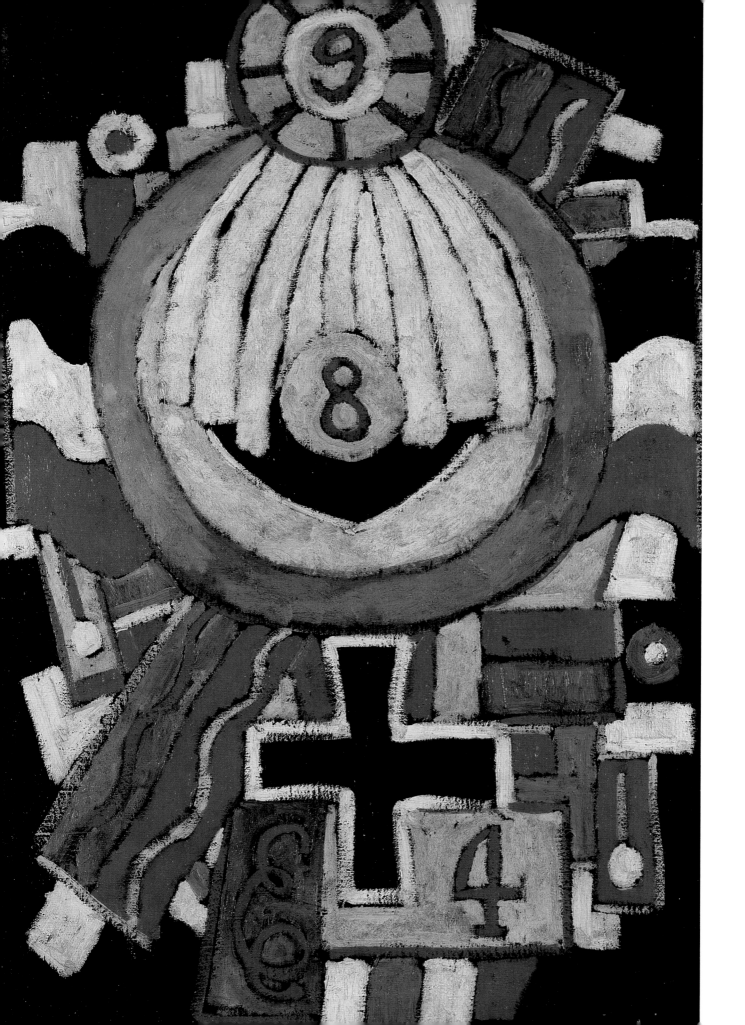

Rönnebeck—died in battle on the Western Front. A short time later, Rönnebeck himself was seriously wounded and sent to a Berlin hospital. In many important ways, this turn of events in late 1914 signaled the start of Hartley's shift to a new, less enthusiastically subjective order. A shift of some kind would have been inevitable, given that his imagery was German and that Germany was now the enemy of Western nations.

Hartley remained in Berlin well into the war, leaving only in December 1915 when cables from New York sending him needed cash were no longer reliably getting through. After von Freyburg's death, he initiated a series of paintings, twelve of which are known today. The Weisman's *Portrait* (circa 1914–1915) (cat. 15, fig. 14) is a canvas from early in this series. These works are many things at once—a memorial to von Freyburg and an elegiac tribute to the masses of war dead, a major synthesis of modernism's pictorial vocabulary, a heavily coded expression of Hartley's life in Berlin's vibrant homosexual culture and the role of the German military in that culture, a sophisticated reprise of the transcendentalist and Jamesian philosophies Hartley admired, and an outpouring of the artist's internal and subjective response to his own situation in Berlin as the world waged war. Before starting the series, he explained to Stieglitz what he was after in this way:

There is something beyond the intellect which intellect cannot explain— There are sensations in the human consciousness beyond reason— and painters are learning to trust these sensations and make them authentic on canvas. [T]his is what I am working for.

Clearly sharing William James' embrace of subjective experience as the core of reality, these words read like a profession of faith and demonstrate that Hartley had at last clarified what he wanted to accomplish in his art.

The panoply of motifs from the German military uniform—cockades, spurs, insignia, plumes, Iron Crosses, spiked helmets, regimental numbers, colorful regional emblems—parade across Hartley's canvases. The animated patterning, brilliant hues, and syncopated compositional schemes express the forceful energy of militarized Berlin that Hartley loved. While he was definitely against the war and, as noted, had already suffered from it, his depictions of military paraphernalia are nonetheless naively cloudy about his political views. Hartley would have us believe the paintings are apolitical. Like the paintings he produced before the fall of 1914, these canvases record his daily experience of metropolitan Berlin—a dynamic city now beginning to reel from the war. Hartley himself continued to stress this atmosphere. The War Motif paintings, he said in 1915, "are characterizations of the 'Moment,' everyday pictures, of every day, every hour."[51] To Stieglitz, he also confided his artistic goals, saying he wanted "just one thing— the brave and difficult idea of seeing life in the real and vivid term[s] of

FIGURE 14 • PORTRAIT, circa 1914–1915. Oil on canvas.

the moment and making that suffice— never once to lose that beauty of the moment which emblazons itself upon the sky of one's existence."[52]

When Hartley returned to New York, Stieglitz quickly arranged an exhibition of the paintings; it was held in April 1916. In his artist's statement accompanying the show, he responded defensively to rising wartime tensions in his homeland. "The forms are only those which I have observed casually from day to day," he wrote. "There is no hidden symbolism whatsoever in them; there is no slight intention of that anywhere. Things under observation, just pictures of any day, any hour. I have expressed only what I have seen."[53] While these words plainly are in keeping with what he had been saying about the paintings, his assertion of "no symbolism" shows he had been made aware that art depicting German military uniforms—whether abstract or not—would not go over well in the America of 1916. Although the United States would not enter the war until April 1917, such horrors as the German U-boat sinking of the passenger ship *Lusitania* in May 1915 (in which nearly two thousand people, including 128 Americans, died), coupled with news reports and a major propaganda campaign conducted by Great Britain, had turned popular sentiment strongly against Germany.[54] This sentiment affected life at every level. For example, sauerkraut and hamburgers were euphemistically redubbed "liberty cabbage" and "liberty sandwiches," and the names of towns, streets, and even families were changed to rid them of any German association.

As one contemporary put it, "[S]omehow everything German gave me the creeps."[55]

There was perhaps an additional reason for Hartley's defensive tone about his German paintings—a wish to deflect attention away from their homosexual content. Those who knew the artist was gay might have also understood that the young German officer memorialized likely had had a special love relationship with the artist. Thus the "no hidden symbolism whatsoever" disclaimer may also have been made to distract attention from this aspect of these complicated paintings.[56] Unfortunately for Hartley, at the very moment he had finally found a covert way to infuse his homosexual identity into his art, he needed to abandon it and find relatively neutral subjects.

Despite the anxieties expressed and hinted at in his artist's statement, Hartley had anticipated that his new paintings would be warmly received. He knew that they constituted his best work to date and that they stood on par with the finest examples of avant-garde art produced anywhere. However, critics mainly saw the imagery as containing "all the pomp and circumstance of war."[57] And while none of them maligned the work as pro-German or expressed awareness of its sexual content in print, their praise was tepid at best. This reaction, combined with weak sales, caused Hartley great disappointment. Depression troubled Hartley before and after this show. In early 1916, he had visited the Croton-on-Hudson home of his friend the art patron Mabel Dodge, but his dark mood finally forced her to ask him to leave.[58]

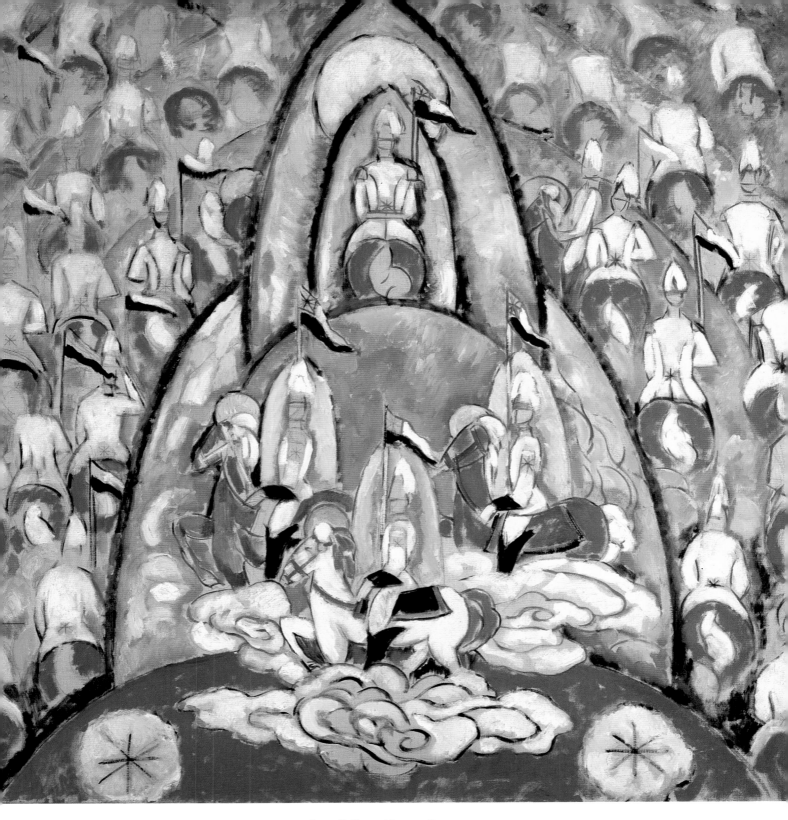

FIGURE 15 • THE WARRIORS, 1913. Oil on canvas, Curtis Galleries, Minneapolis.

A year earlier Hartley had written Stieglitz, "I have achieved a nearness to the primal intention of things never before accomplished by me[.] The germans [sic] have helped me in this—[.]"[59] Now, however, he was painfully beginning to see that, to survive as an artist, he would need to forsake both the Germans and the painting achievement that resulted from his Berlin experience. He would have to do more than simply jettison the German military uniform from his repertoire. A growing conservatism, rising nationalist fervor, and creeping distrust of extreme artistic experiments—all of which stemmed from the enormous brutality and shock of World War I—would combine to make Hartley leave abstraction behind as well. He would, in effect, have to redefine himself as an artist.

To come to terms with Hartley's pendulum swing between his pre-1916 faith in subjectivity and his post-1917 allegiance to objectivity, it is essential briefly to review the unparalleled enormity of the war itself, as well as to get a sense of its cultural aftermath. "The conflict of 1914 to 1918 was, in fact, the Great War," the historian R. J. Q. Adams tells us. "It changed in some way the lives and futures of every man and woman on the planet."[60] Gertrude Stein, who drove a relief wagon for the American Fund for French Wounded, characterized the abrupt cultural shift that the war produced by commenting that it was only *after* World War I that "we had the twentieth century."[61]

Probably the clearest way to take in the scale of World War I is to examine its casualty statistics.

Approximately thirteen million men in uniform died. Comparison helps to see why that figure was, and remains, so staggering. "More than twice as many men died in action or of their wounds in the First World War as were killed in all major wars between 1790 and 1914," the historian George Mosse clarifies.[62] Prior to 1914, the single most deadly European conflict within the stretch of living memory had been the 1870–1871 Franco-Prussian War, with a death toll of less than two hundred thousand.[63] The American Civil War of the 1860s had, like World War I, lasted four years, but even its appalling cost—roughly six hundred twenty thousand dead—paled in comparison.[64] Nearly two generations had elapsed since these major wars had been fought. As the eminent military historian A. J. P. Taylor points out, in 1914 "no man in the prime of his life knew what war was like."[65] It is perhaps impossible to imagine, then, the depth of people's shock as the war dragged on and on and the death tolls rocketed ever higher. To take just one example, on July 1, 1916, the first day of the three-month-long Battle of the Somme, sixty thousand of one hundred ten thousand advancing British troops were killed in a slaughter that lived on in the memory of the troops as "the Great Fuck-Up."[66] When the guns finally went silent, a million men on both sides had died in this sensational encounter alone.[67]

Most of the soldiers who died in the war were, of course, quite young. In October 1916 Great Britain, for the first time in the history of its empire, enacted a conscription law. By war's end

two years later, over half of that nation's infantry was made up of men under nineteen years of age. Virtually an entire generation of male youth from Western European countries was sacrificed to the carnage. Traveling through England, France, and Germany to this day, one is sharply reminded of the tender ages of many of the fallen by a popular form of grave-marker that includes a mounted metal picture of the deceased. The soldiers who gave their lives from 1914 through 1918 still keep a silent vigil in European cemeteries.

It is no wonder that the British poet and novelist Robert Graves, who served on the war's Western Front, called it "the Sausage Machine . . . because it was fed on live men, churned out corpses, and remained firmly screwed in place."[68] Indeed, with this war killing became mechanized routine. Industrial manufacture and technological advances made a wholly new, highly efficient form of annihilation possible. Barbed wire, tanks, airplanes, tear gas, the modernized machine gun, and bunkered trenches—all were put to first-time military use in this war. These accoutrements of modern industry helped inure people to the heavy losses. One reporter, writing in the *New York Times* on November 5, 1918, a week before the Armistice, observed that "death itself has become so familiar as to lose something of its grimness and more of its importance."[69]

A related factor contributing to the unprecedented carnage of World War I was the inability—often the stubborn unwillingness—of French and British military elite to grasp that the advent of modern weaponry and powerful German defenses meant that new offensive tactics needed to be devised. Countless deaths were attributable to officers' refusal to understand that German trenches could not be effectively overcome by time-honored frontal maneuvers in which troops advanced in formation. German gunners, secure in their sheltered trenches, cut down wave after wave of these troops. As the historian Paul Fussell reasons in his landmark book, *The Great War and Modern Memory*, "The [military] planners assumed that these troops . . . were too simple and animal to cross the space between opposing trenches in any way except in full daylight and aligned in rows or 'waves.' It was felt that the troops would become confused by the subtle tactics like rushing from cover to cover, or assault-firing, or following close upon a continuous creeping barrage."[70] As the World War I chronicler Trevor Wilson sums it up, this means of bloodletting established "the character for which [World War I] has ever since been remembered: huge offensives for grandiose objectives which accomplished nothing tangible beyond mighty losses of life on both sides."[71]

The experience of the war and reconciliation to the truth of such massive losses—so many sons, husbands, and fathers now silenced—engendered a disillusionment about most things that previously had mattered. For a start, in Fussell's words, "it reversed the idea of progress." He takes this point from Henry James, who only one day after England's declaration of war foresaw this lesson that the fight would exact. "The plunge of civiliza-

43

tion into this abyss of blood and darkness," James wrote, "is a thing that so gives away the whole long age during which we have supposed the world to be, with whatever abatement, gradually bettering."[72] This loss of idealism is probably what Gertrude Stein was alluding to in her remark quoted above about the twentieth century not really having begun until after World War I. Ernest Hemingway expressed this new sobriety and wariness in his 1929 novel depicting the tragedy and destruction of the war, *A Farewell to Arms*, suggesting that, "Abstract words such as glory, honor, courage, or hallow were obscene beside the concrete names of villages, the numbers of roads, the names of rivers, the numbers of regiments and dates."[73] Marsden Hartley voiced his own disillusionment and sense of a marked difference wrought by the war well before it was over, writing to Stein in 1915, "How changed the world is since we last saw each other. I think the world is faceless— I think it has no sight— I know it is heartless."[74]

The lost faith and sense of heartlessness about the world fueled a cultural phenomenon known as the Lost Generation. A label that has come to mean many things in differing contexts, it initially derived from a French hotel proprietor's comment to Gertrude Stein in 1925 that youth who spent formative years fighting the war were "a lost generation."[75] Hemingway agreed and used the statement, which he felt applied well to his peers, in the epigraph that opens his important 1926 novel, *The Sun Also Rises*, a tale focused on a

set of aimless, disillusioned expatriates in postwar Europe. Fierce alienation from the dominant culture, combined with apathy and cynicism, plagued a wide caste of intellectuals who adopted this mindset in the wake of the war. This outlook surfaced often in postwar literature, most notably in such novels as F. Scott Fitzgerald's *Tender Is the Night* (1934). But it was a pressing doubt troubling many in real life as well. Fussell rightly observes that Lost Generation disillusionment gave rise to "the essential modernist anti-hero, the man things are done to or the person whose power of action is severely restricted. The victim of mass conscription and military discipline is a version of Kafka's Gregor Samsa, Hemingway's Jake Barnes, Eliot's Prufrock, and Beckett's Krapp."[76]

Another spiritual wound sustained as a result of the Great War was a deep fear of risk. Having faced chaos and death on an unprecedented scale, the world longed for reassurance and gravitated toward stable cultural anchors. A trend toward cautious action and conservative values spread around the globe and took firm hold. Characterizing this pervasive attitude well in his 1941 book *The Ground We Stand On*, the American author John Dos Passos wrote, "In times of change and danger when there is a quicksand of fear under men's reasoning, a sense of continuity with generations gone before can stretch like a lifeline across the scary present."[77]

Closer to our own time, and describing post-World War I Germany, the cultural historian Peter Gay succinctly termed the galvanizing force of this

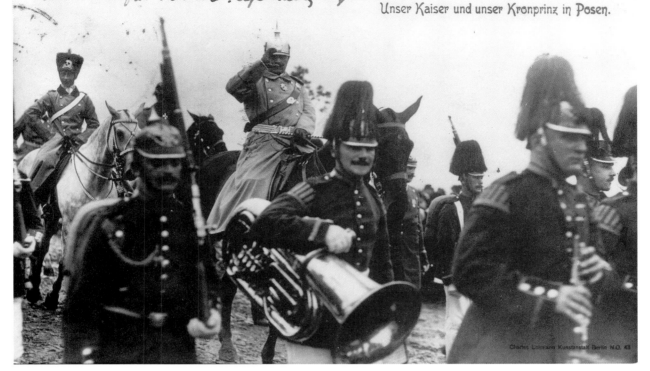

I like what your spanish waiter said about the numbers — I have seen some wonderful ones here, especially a green 3 —

Unser Kaiser und unser Kronprinz in Posen.

Unser Kaiser und unser Kronprinz in Posen (Kaiser Wilhelm II), *1913. Postcard from Marsden Hartley, postmarked August 30, 1913, to Gertrude Stein, Yale Collection of American Literature, Beinecke Rare Book and Manuscript Library, Yale University.*

conservatism a "hunger for wholeness."[78] That hunger, or ache, took unique form in each cultural setting. In the United States, it manifested itself in many ways. The nation emphasized its physical distance from Europe and Asia by refusing to join the League of Nations that its own President Woodrow Wilson had envisioned and helped create. Further, Congress passed laws virtually shutting off the flood of foreign immigration to America that had flowed for half a century. This insular mood begot a pronounced nationalism. As Dos Passos suggested, interest in comfortable customs and traditions surged. References to history, especially to supposedly golden moments in time past, became ubiquitous in political and popular par-

lance. An emphasis on the importance of place and, with it, connection to one's spot on the earth developed along with a keen focus on local and regional folkways.[79]

These nativist impulses produced a new order of the day for artists, writers, and cultural critics, who became involved, as the historian Michael Steiner described it, in a "search for the primal spatial structure of the country, for what was perceived to be the true, underlying fault lines of American culture."[80] By unmistakable implication, the project of identifying this America was directly opposed to the subjectivity and relativism of prewar modernism. Certainly, so the rising conventional wisdom went, truly American art, writing,

and criticism took sustenance from commonplace wisdoms, verities the land teaches, and long-standing traditions—and not from the precepts of hothouse radicalism or rebellious experimentation. Pictorially, this trend championed an unadorned realism that attempted a straightforward depiction of plain folk and everyday life.

Such was the unsettling climate faced by members of the avant-garde after 1914. Their philosophy of an unfettered intuitive expressiveness came under attack. Modernism's revolt, led by thinkers such as Friedrich Nietzsche, Sigmund Freud, William James, George Santayana, Henri Bergson, and James Joyce, represented a worldview that stood in stark contrast to the consoling stability that surfaced so powerfully after World War I. To be sure, a number of artists and intellectuals persevered in their commitment to subjectivity in these years, but in doing so they bucked a dominant drive toward restraint, realism, and nationalist-oriented expression.

In his book *Esprit d'Corps: The Art of the Parisian Avant-Garde and the First World War,* the art historian Kenneth Silver examines the impact that this atmosphere had on forward-looking Parisian artists.[81] Already in the late 1910s, Silver shows, Picasso was turning for inspiration to the early-nineteenth-century neoclassical painter Jean-Auguste-Dominique Ingres, Juan Gris was drawing *d'apres* Cézanne, and Matisse's canvases made references to Ingres and Rodin. Through the 1920s, these and other vanguard artists jettisoned cubism and other forms of abstraction—now con-

sidered a "disease" and an "obsession with 'personality at all costs'"—and embraced historicizing styles.[82] The French critic Julian Benda, in his 1928 book *The Treason of the Intellectuals,* went so far as to indict modernists for inciting the day's chaos and insecurity through their promotion of intuition over reason.[83]

In America, the cultural critic Thomas Craven led a similar antimodernist assault. Through Craven and others, modernism became demonized as a cultivated European flower that had no true ground on this side of the Atlantic. That label quickened the resolve against modernism in a country where the movement we now call regionalism was emerging as the needed artistic and cultural antidote to the anomie of the postwar years. While regionalism is most often associated with the crises America faced in the 1930s—the Great Depression instigated by the 1929 stock market crash, the Dust Bowl, and ferocious labor unrest, among others—and was indeed a potent response to the general hunger for stability of those years, it was in fact well under way in the early 1920s and can be said to have first developed in the wake of World War I.

As the historian Michael Steiner reminds us, "More than any other regional theme, sense of place offered a promise of order, security, and self-understanding."[84] Americans' connection to *this* land, this place was now seen as the essential project for the arts to explore. As the critic Harold Stearns expressed it in 1922, "Thought is nourished by the soil it feeds on."[85] That year he edited

Civilization in the United States: An Inquiry by Thirty Americans, an anthology of incisive essays all articulating the then nascent regionalist point of view. For Stearns and his contributors, the task of building art and literature upon a distinctly American cultural expression was a reconstruction project that had to be undertaken from the ground up.[86]

Small-town and rural America, which offered greater practical access to the "soil," emerged as the predominant locus for the reconstruction or regeneration at hand. As one New York art critic put it in 1930, "[T]here was a tendency on the part of many to exalt Main Street against Park Avenue or Beacon Hill."[87] Regionalism, then, concerned the discovery of the vibrant soul of the country—not in its city centers, not among its genteel society, but in the heartland and in the perceived decent character of common folk.

While the movement to identify and express this soul led artists and writers to focus mainly on the Midwest and South, the preoccupation with regionalist themes was open to generalization. This was readily reflected in the popular literature of the day. For example, the five best-selling American novels of the 1930s, when regionalism reached its peak, were Margaret Mitchell's Gone With the Wind, Erskine Caldwell's God's Little Acre, Pearl S. Buck's The Good Earth, John Steinbeck's The Grapes of Wrath, and Dale Carnegie's How to Win Friends and Influence People.[88] All but Carnegie's book emphasized a rooted connection to the land.

Two American novels—Willard Huntington Wright's The Man of Promise (1916) and John T. Frederick's Green Bush (1925)—strikingly highlight the contrast between cultural attitudes, particularly about the arts, as they existed before World War I and after it.[89] Wright's novel appeared a year after the publication of his What Nietzsche Taught, a combination primer-promotional piece on that iconoclastic German philosopher's ideas. He used the novel to spread the word further. His protagonist, Stanford West, is a veritable Nietzschean Übermensch (superman) who has grown up on the prairie but has a gift with the pen. He moves to the city to pursue his talent. Though his childhood love joins him there and they marry, their marriage falters when she insists that they lead a bourgeois life. Increasingly, West ignores her, and the other women who drag on his talents, and devotes himself to writing. The situations that arise from this struggle are never easy, and Wright's unmistakable moral is that writers and artists must strive at great personal cost and against pressures for conformity to realize their genius. Green Bush tells the same story—but in reverse. Here the protagonist, Frank Thompson, likewise springs from the soil (a Midwestern farm) and is blessed with above-average intelligence. He goes off to an urban university to study Balzac and Rodin. His father's sudden death pulls him back to the farm and to his childhood sweetheart. Against the wishes of his mother, who wants to see her son lead a better life away from the farm, he forgoes his promising future in the city, marries

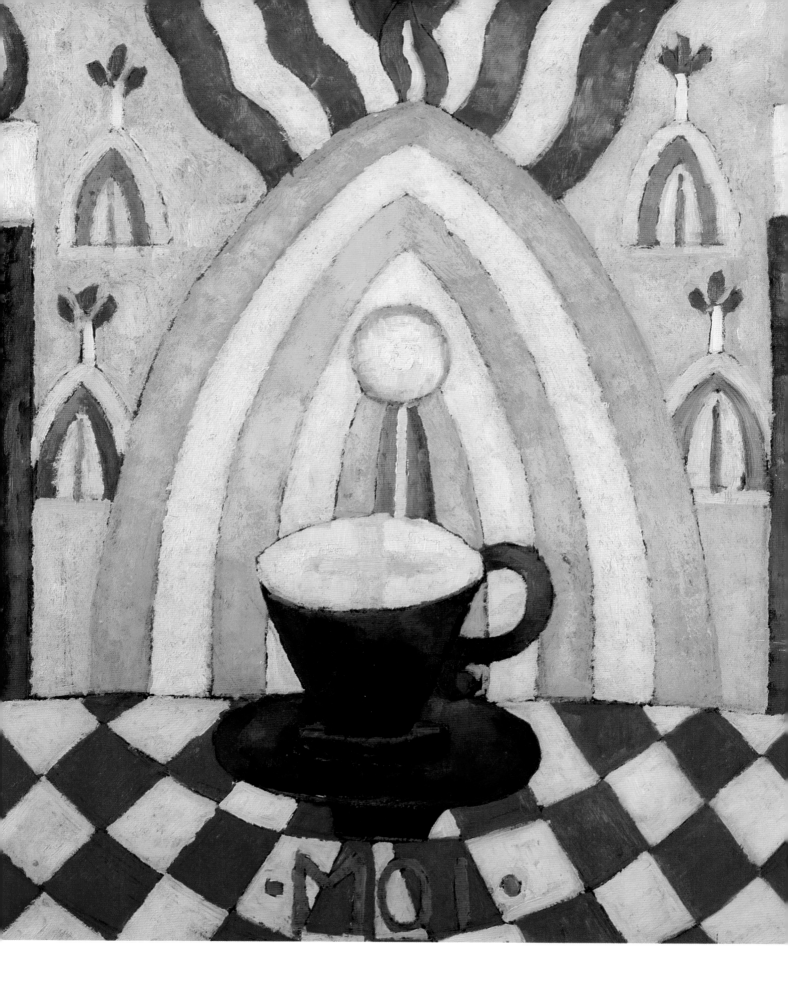

49

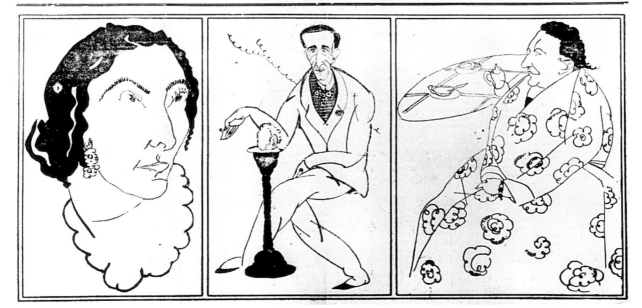

Djuna Barnes, Three American Literary Expatriates in Paris (Mina Loy, Marsden Hartley, and Gertrude Stein), New York Tribune, November 4, 1923. Papers of Djuna Barnes, Special Collections, University of Maryland at College Park Libraries.

his local love, and chooses to devote his life to the land as a farmer.

Like Frank Thompson, Marsden Hartley would ultimately reignite his love of the land after a period of pursuing the role of *Übermensch*. He played out the prodigal-son scenario as predictably as did most artists of his generation. Like Andrew Dasburg, André Derain, Kasimir Malevich, Pablo Picasso, Georgia O'Keeffe, and many others, he left abstraction and its pursuit of intuition behind. He retooled his thinking to accommodate himself to a much changed cultural environment. Initially, he fell in with fashion and rejected his former subjective leanings. Eventually, however, he came to understand that a representation of objective fact and an emotional response to subject matter could *both* be accommodated, even synthesized, in his art.

The war forced Hartley's return to the States, just as it forced him to reconsider his artistic objectives. Among the first canvases he painted back on American shores is *One Portrait of One Woman* (1916) (cat. 17, fig. 16), his homage to Gertrude Stein. In it, he started his dual attempt to find a place for himself at home and a new imagery, one purged of German references. The painting's mixture of symbolic motifs and bold colors contained within a tightly organized pictorial matrix continues the style of his German paintings.

FIGURE 16 • ONE PORTRAIT OF ONE WOMAN, 1916.

Oil on composition board.

That summer, he joined the cast of characters who spent what was later known as the Great Provincetown Summer together. The Massachusetts resort town hosted artists and writers—including Hartley, Charles Demuth, Eugene O'Neill, and John Reed—who escaped New York and tried to ignore the depressing news of the war. There Hartley continued working in his modernist pictorial idiom and made stylized paintings of seaside scenes, such as *Elsa* (1916) (cat. 16, fig. 17).

During the winter of 1917 Hartley and Demuth traveled to Bermuda. In ill health and profoundly depressed by the war and the collapse of his artistic direction with the weak reception of his German paintings, Hartley contemplated his next step. "I am really tired out spiritually by the loss of illusions," he wrote Stieglitz in February. "I find the world a silly place and this in my sanest moments."[90]

That April, while he was still in Bermuda, the United States entered the war. There, Hartley penned a poem voicing his response to the killing:

> *Shepherd of the morning*
> *wailing.*
> *Anguishes have I well*
> *crushed with the spell,*
> *saw this, my weakling herd*
> *to death-throes conferred,*
> *stood stark beneath*
> *the shadow tree,*
> *saw them die*
> *speechlessly.*

> *What shall I, shepherd*
> *who cannot herd my lambs*
> *or sheep,*
> *and cannot sleep.*[91]

This bleak outlook would soon dissipate, as a path toward change opened up for him. In June 1918 he lit out for New Mexico, having been invited there by Mabel Dodge, who had moved to Taos. If he was starting to contemplate a return to a more strongly representational form of painting and was seeking firm grounding in the land as a means of breaking out of his artistic dead end, what better place to do so and to "discover America" than in the territory of the mythic American Wild West? And indeed, while there he found a new course of action. "I am the American discovering America," he boasted in a 1918 essay, "America and the Landscape."[92] In another piece, published two years later, he echoed the sentiment just then beginning to circulate. "[I]t is our geography that makes us American," he claimed. "It is from the earth [that] all things arise."[93] If, as he offered, "America as landscape is profoundly stirring," then to find the appropriate artistic voice for it, "the American painters must first learn to arrive at firsthand contact with it."[94] That was precisely Hartley's new objective, one he would pursue with a vengeance. As he wrote to Stieglitz, he was "copying nature as faithfully as possible."[95] The pastel drawings of arroyos and paintings of sweeping New Mexican vistas in the Weisman

FIGURE 17 • ELSA, 1916. Oil on paper mounted on cardboard.

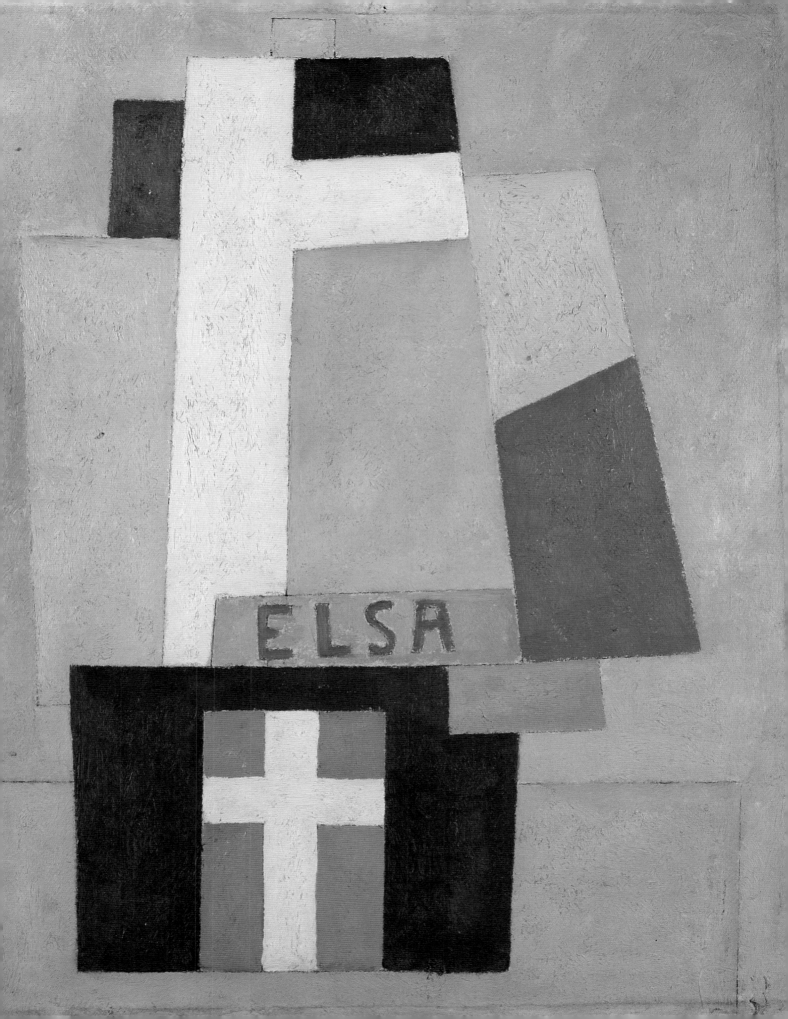

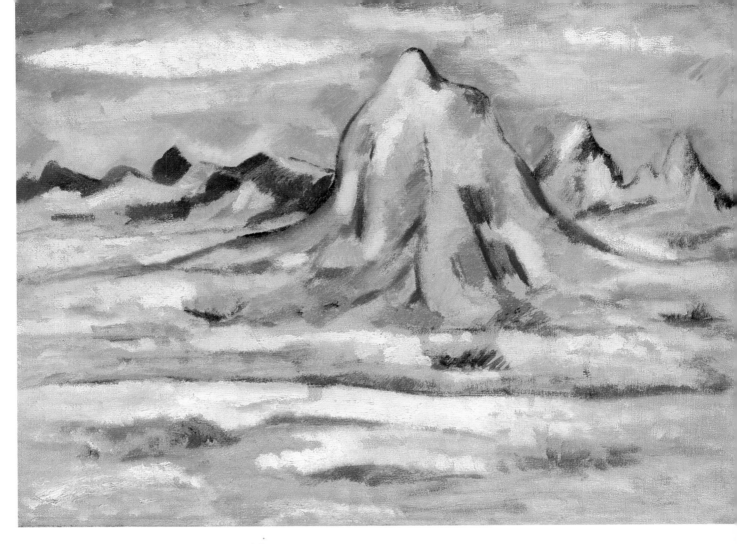

▲ **FIGURE 18** • **NEW MEXICO LANDSCAPE**, 1919. Oil on canvas.

◀ **FIGURE 19** • **SANTOS, NEW MEXICO**, 1918–1919. Oil on composition board.

*"There will be an art in America only when there are artists big enough and really
interested enough to comprehend the American scene. Whitman was a fine
indication of promise in that direction." (1918)*

*"The return to realism is more than immanent, but not a return to photographic
'paper painting' of the French Academy. It will be a sturdier kind of realism, a
something that shall approach the solidity of landscape itself." (1918)*

FIGURE 20 • **NEW MEXICO,** circa 1918. Pastel on paper.

FIGURE 21 • **NEW MEXICO LANDSCAPE,** 1918. Pastel on paper.

FIGURE 22 • ARROYO HONDO, VALDEZ, 1918. Pastel on paper.

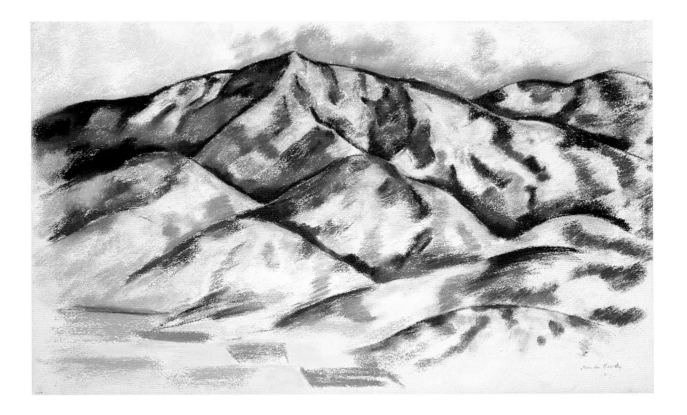

FIGURE 23 • LANDSCAPE NO. 8, 1919. Pastel on paper.

collection (cats. 21, 23, 39–42, figs. 18, 24, 20–23; pp. 53–56) show Hartley in the process of reshaping his art and his ideas. They demonstrate his struggle to forge a new realism, as he said, "a sturdier kind of realism, a something that shall approach the solidity of landscape itself."[96]

Hartley was strident when first trying on this new set of conceptual clothes. In a 1922 essay, for example, he argued that "The eye with a brain in it is what every artist should covet. Mental or intellectual ocularity is the degree he must expect of himself."[97] This same notion is a refrain of his statement in 1919 that "real art comes from the brain, as we know, not from the soul."[98]

During the 1920s and early 1930s, Hartley readily took part in the cultural swing toward conservatism. He wanted his art to be as "American" as possible—and, for the time being, that also meant being resolutely objective. "Very much on the ground— . . . as objective as I can make it," as his friend Georgia O'Keeffe would say of her own transition to representational still lifes in 1924.[99] Hartley's many still lifes of these years, such as *Basket and Napkin* (1923) (cat. 25, fig. 27, p. 59) and

▲ FIGURE 24 • WESTERN FLAME, 1920. Oil on canvas.

▶ FIGURE 25 • FLEURS D'ORPHÉE, 1928. Oil on canvas.

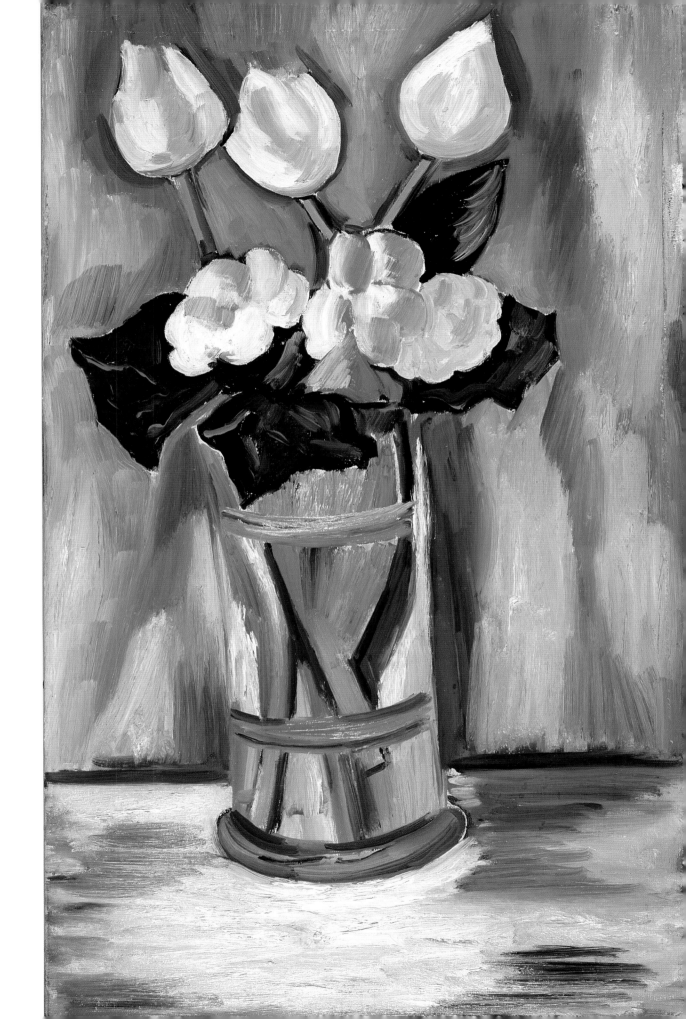

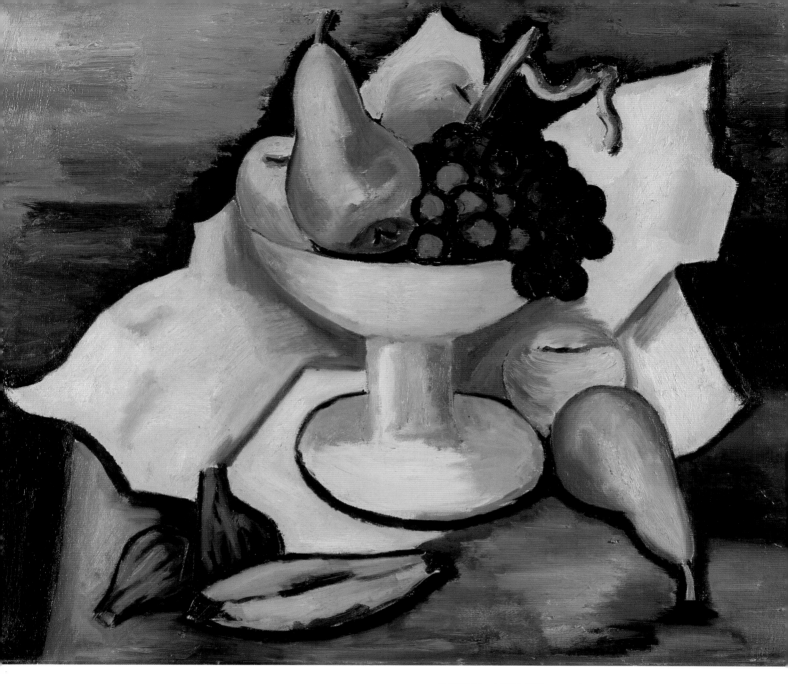

▲ FIGURE 26 • STILL LIFE, 1923. Oil on canvas.

▶ FIGURE 27 • BASKET AND NAPKIN, 1923. Oil on canvas.

"The eye with a brain in it is what every artist should covet. Mental or intellectual

ocularity is the degree he must expect of himself." (1922)

Still Life (1923) (cat. 24, fig. 26), show him working hard to be the "scientific spectator of all principles of nature," as do his host of landscape canvases, including *Landscape, Vence* (1925–1926) (cat. 27, fig. 2; p. 16).[100] A few spare forms depicted with exacting strokes and based on careful observation, seen in this and many other 1920s works, reveal the rational Hartley. The studied paint-handling and penetrating pictorial analysis of his subject—here, a valley in the south of France—show him in full retreat from expressive symbolism and subjectivity.

Hartley began to backpedal and soften his "scientific objectivity" rhetoric in the first half of the 1930s, years when the domination of regionalism reached its peak. He began allowing greater room for personal perception. Hartley scholar Gail Scott rightly points to his intense study of Cézanne

in 1926 and 1927, his work in Massachusetts' Dogtown glacial moraine in 1931 (cats. 32, 33, figs. 29, 30; p. 60), his use of a friend's library of occult literature in 1932, and his winter sojourn in the Bavarian Alps in 1933 (cats. 44, 45, figs. 31, 32; pp. 62, 63) as a significant series of experiences leading Hartley gradually to return to his former orientation toward the subjective.[101] The art historian Bruce Robertson also points out that *Eight Bells Folly* (1933) (cat. 31, fig. 28; p. 61), the artist's symbolic portrait made after the 1932 suicide of his friend the poet Hart Crane, was Hartley's first overt inclusion of a personal reference in his art since his German days in the 1910s.[102]

The tentative steps he took back toward subjectivity during the early and mid-1930s became increasingly assured ones in his late work in Nova Scotia and Maine. Even in 1933 he was able to

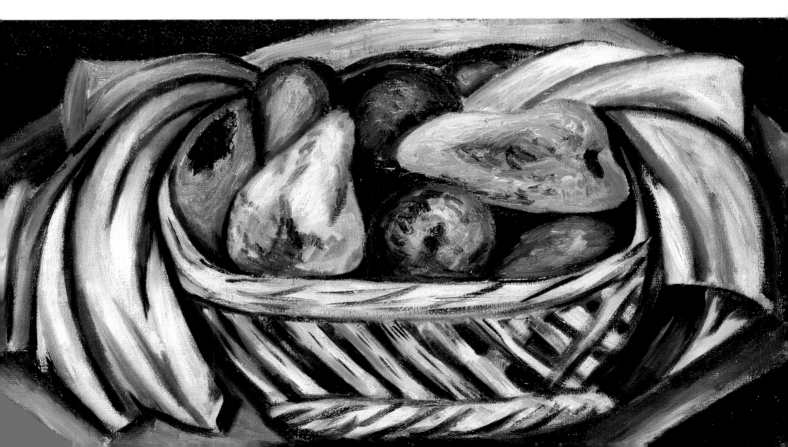

▲ FIGURE 28 • EIGHT BELLS FOLLY: MEMORIAL TO HART CRANE, 1933. Oil on canvas.

◄ FIGURE 29 (top) • DOGTOWN, THE LAST OF THE STONE WALL. 1934. Oil on academy board.

◄ FIGURE 30 (bottom) • DOGTOWN, 1934. Oil on Masonite.

"[I]t is our geography that makes us American. It is from the earth

[that] all things arise." (1919)

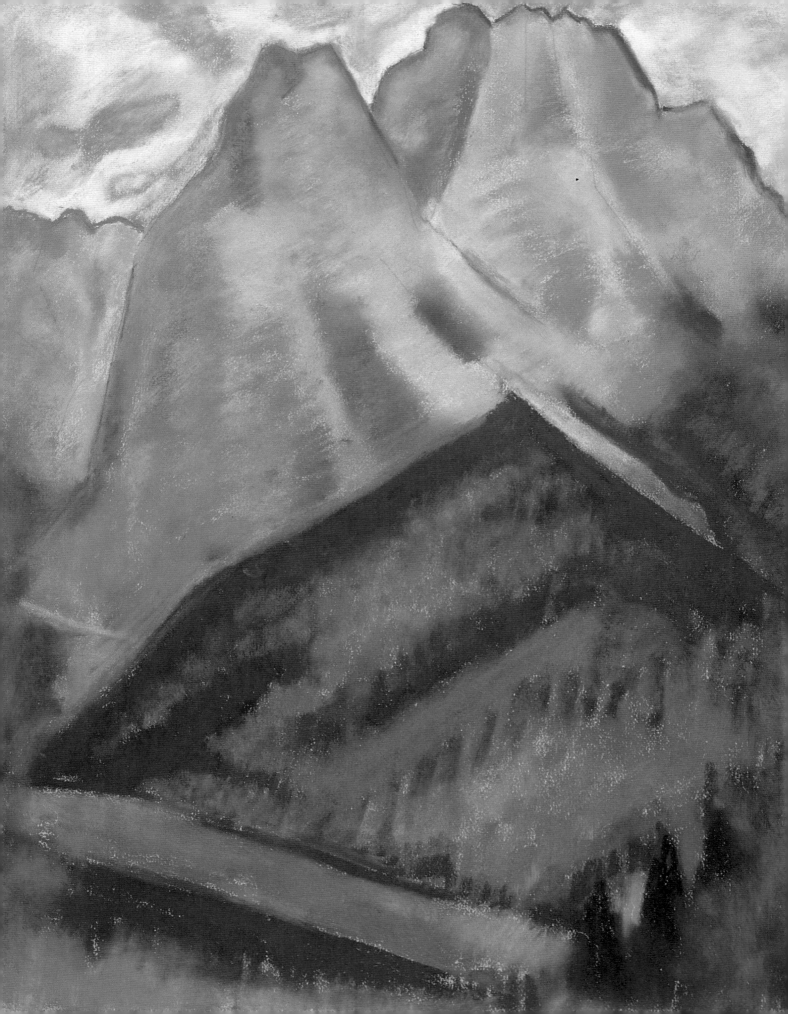

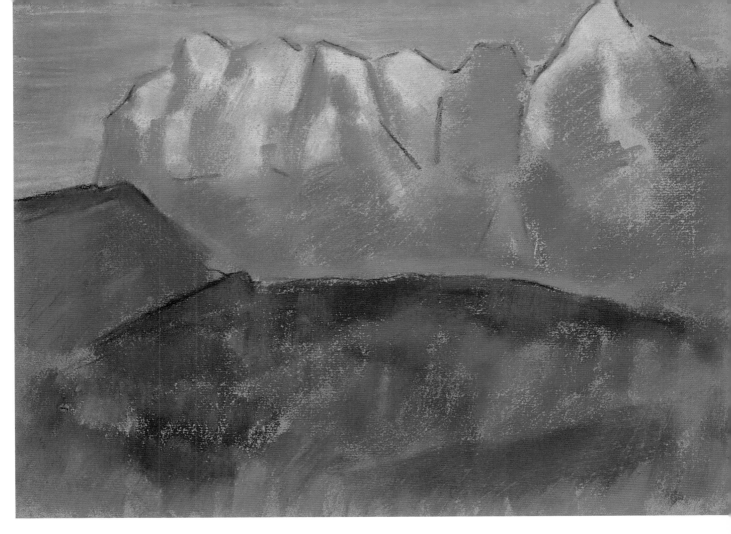

▲ FIGURE 31 • ALPSPITZE, GARMISCH-PARTENKIRCHEN, 1933. Pastel on rose paper.

◄ FIGURE 32 • THE WAXENSTEIN, GARMISCH-PARTENKIRCHEN, 1933. Pastel on gray paper.

"There is something beyond the intellect which intellect cannot explain—

There are sensations in the human consciousness beyond reason— and painters are

learning to trust these sensations and make them authentic on canvas.

[T]his is what I am working for." (1913)

"My pictures are bound to the mystical more and more for that is what I myself am

more and more. . . . I belong naturally to the Emerson-Thoreau tradition and I know that

too well. It is my native substance." (1933)

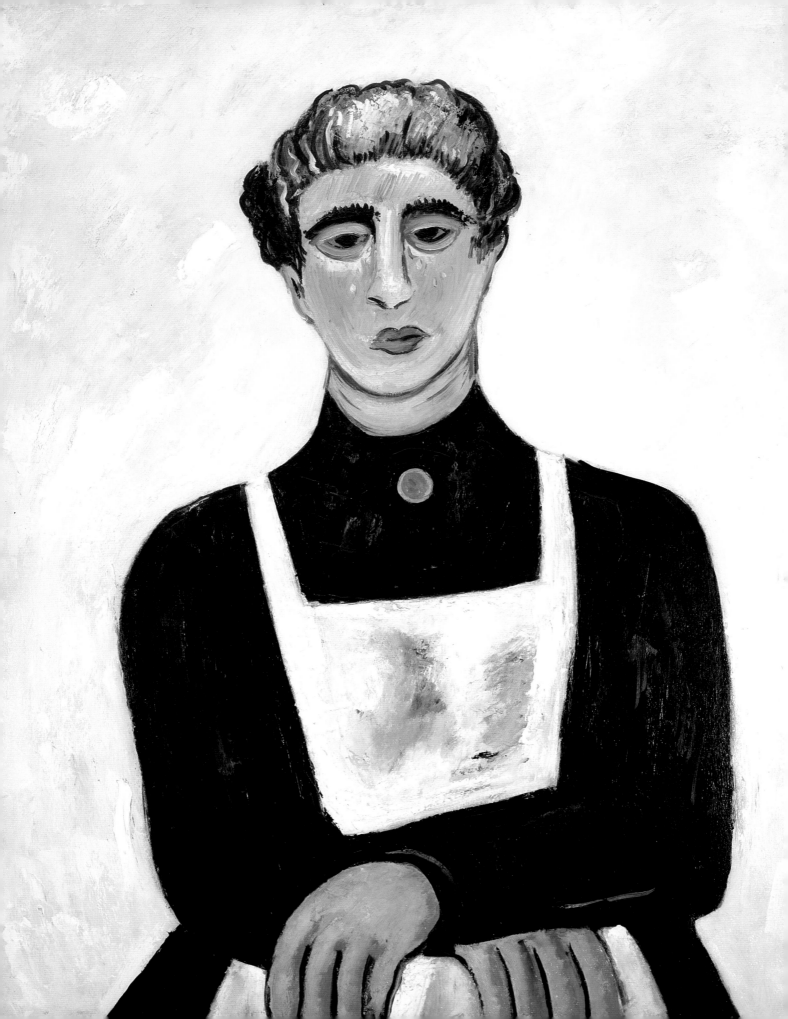

assert that a reconciliation with his earlier artistic self was imminent. "My pictures are bound to the mystical more and more," he wrote to Downtown Gallery dealer Edith Halpert, "for that is what I myself am more and more. . . . I belong naturally to the Emerson-Thoreau tradition and I know that too well. It is my native substance."[103] His overseas wanderings—which continued through the early 1930s—ended in 1935 when he moved to Nova Scotia and then back to Maine.

His return to the state of his birth was, in part, a calculated maneuver. The art historian Donna Cassidy interprets Hartley's late embrace of Maine as a response to market forces, demonstrating his desire to position himself as "the painter from Maine" in a time when regionalism was key.[104] She is right to argue that Hartley cared greatly about the sales of his work and that his language in this period was at times burdened by a heavy regionalist accent. Yet, while the artist's late works reflect these interests, they are ultimately this *and more.*

"I returned to my tall timbers and my granite cliffs," Hartley clarified in 1938, "because in them rests the kind of integrity I believe in and from which source I draw my private strength both spiritually and esthetically."[105] Wisdom from maturity and insight from experience eventually led Hartley back to his origins—geographic, conceptual, and artistic. He began his career "rendering the God-spirit in the mountains" of Maine and returned in the end to this same source of personal and artistic sustenance. In the early 1910s, he said he wanted his art "to express a fresh consciousness of what I see + feel around me— taken directly out of life[.]"[106] In his later years, he recognized again that this should be his goal. He reacquainted himself with American transcendentalism and Jamesian radical empiricism. For both these philosophical approaches and for Hartley, the subjective was an essential aspect of the whole of life, one that carried the sensitive observer to crucial insight. In the late 1930s Hartley declared that he wanted his art to capture "a vividly revealing

65

◄ FIGURE 33 • MARIE STE. ESPRIT, circa 1938–1939. Oil on academy board.

FIGURE 34 • FISHING VILLAGE, 1937. Lithographic crayon and white chalk on gray cardboard.

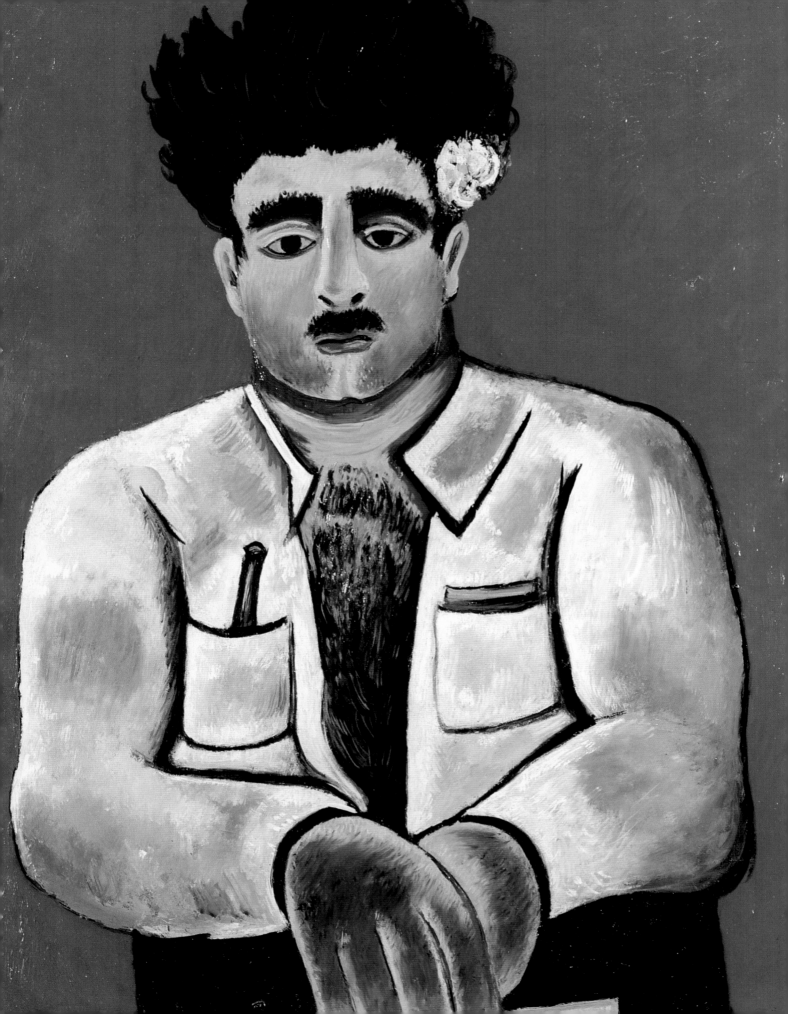

aspect of enlarging experience."[107] This enlarging experience—witnessed in Maine's tide pools and on its mountaintops—is the ultimate content of his final canvases.

Fortuitously, Hartley could reconnect with his ideological roots in American transcendentalism and position himself as a contemporary link in a very American chain. Gradually he came to realize that he could embrace subjectivity again because it was part of a revered and established tradition. In this regard, Donna Cassidy names Winslow Homer and Albert Pinkham Ryder as linchpins in the "regional ancestry" of Hartley's late Northeastern imagery.[108]

The Weisman Art Museum has many riches from Hartley's final episode. *Adelard the Drowned, Master of the "Phantom"* (cat. 34, fig. 35) and *Marie Ste. Esprit* (cat. 36, fig. 33; p. 64) convey the heroic simplicity Hartley so loved about Northeasterners. He celebrated these craggy fisher folk, drawing from his intimate knowledge of their labors. They represent Hartley's own interpretation of the regionalist penchant for depicting plainspoken common people in an unadorned manner. *Fishing Shack and Lobster Pots* (cat. 47, fig. 36; p. 68) and *Fishing Village* (cat. 48, fig. 34; p. 65), both from 1937, record Hartley's sensitivity to the rhythms of Maine life. And *Mount Katahdin* (1940–1941) (cat. 52, fig. 37; p. 69), a black-crayon drawing of

Maine's prominent peak, is an homage to "the God-spirit." In the fall of 1939, having returned from a climb up this mountain, he wrote, "I know I have seen God now." He continued, "The occult connection that is established when one loves nature was complete— and so I felt transported to a visible fourth dimension—[.]"[109] His many paintings and drawings of Mount Katahdin operated, in Hartley's mind, to replicate this "visible fourth dimension" for viewers.

Anonymous, Alty Mason, n.d. Photograph, Yale Collection of American Literature, Beinecke Rare Book and Manuscript Library, Yale University.

FIGURE 35 • ADELARD THE DROWNED, MASTER OF THE "PHANTOM," circa 1938–1939. Oil on academy board. This painting represents Hartley's friend Alty Mason, who died in 1936.

Clearly, Hartley had returned to Maine to get down that which he knew well and best. After a host of changes and maneuvers that he undertook to accommodate himself to the forces in his life—to conceal his homosexuality, to win sales for his paintings, to stay intellectually abreast of the day's cultural trends, to believe himself to be making a valid contribution to the art of his time—he again assumed a passionate belief in a subjective approach. This final choice for an emotive expressiveness shows Hartley returning to the well within him that always served him best.

Had Hartley lived beyond 1943, he would have again found himself in an art world that prized individual experience and abstract experimentation. Although World War I hastened a return to representational art, World War II ushered in a decades-long hegemony of abstraction.

FIGURE 36 • FISHING SHACK AND LOBSTER POTS, 1937. Lithographic crayon and white chalk on gray cardboard.

The New York School of abstract expressionists—the circle that made New York, not Paris, the center of the art world—reacted strongly to the social realist art that fascist and totalitarian regimes promoted in the 1930s as well as to the realism of American regionalism. The critic Benjamin Buchloh goes so far as to call interwar realism a "cipher of regression."[110] Abstract painters after World War II rejected the false salvo of certain and secure artistic conventions as symbols offering cultural stability and, like their modernist forebears, pursued a heroic individualism. Hartley would have found many like-minded friends among the New York School painters. These shifts confirm the point that visual emblems and artistic styles, for all their inherent formal appeal, are, first and always, cultural constructions. Hartley had needed to abandon his prewar abstractions, works hailed today as evidence of his exceptional artistic powers, because after World War I abstraction itself came to be seen as a "disease." Yet by the time his life ended, abstraction and impassioned subjectivity were coming back in vogue.

Unlike the Lost Generation artists and writers who were his peers, Hartley never became a hardened skeptic. Nonetheless, his world fell apart just as radically as did theirs in

FIGURE 36 • FISHING SHACK AND LOBSTER POTS, 1937. Lithographic crayon and white chalk on gray cardboard.

68

FIGURE 37 • **MOUNT KATAHDIN**, 1940–1941. Black crayon on buff wove paper.

the wake of the Great War. While various scholars and critics have probed Hartley's changes of heart, they have only infrequently viewed his shifts and turns in the light of the broader cultural dilemmas of the time. Hartley's conversions were not the mood swings of a petulant temperament, and they cannot be fully grasped outside the context of his highly turbulent epoch. He changed his mind and opened and closed his heart in time with the staggering world events that he witnessed over the course of his life. His art ultimately reflects the savvy and dexterity of this American modern and the impact of world events that forged the twentieth century as we know it. ■

Notes

1 Marsden Hartley to Alfred Stieglitz, December 20, 1912, Yale Collection of American Literature, Beinecke Rare Book and Manuscript Library, Yale University. Hereafter cited as YCAL.

2 Marsden Hartley, "The Business of Poetry," *Poetry* 15, no. 3 (December 1919): 157.

3 Marsden Hartley, "Art—and the Personal Life," *Creative Art* 2 (June 1928): xxxi–xxxvi. As quoted in Gail R. Scott, ed. *On Art by Marsden Hartley* (New York: Horizon Press, 1982), 71.

4 Herschel B. Chipp, *Theories of Modern Art: A Source Book by Artists and Critics* (Berkeley and Los Angeles: University of California Press, 1968); and Barbara Rose, *Readings in American Art: 1900–1975* (New York: Praeger Publishers, 1968).

5 Chipp's and Rose's choice of this Hartley essay, which elevates formal considerations in art over emotional exuberance, likely has everything to do with the trends dominating the art world in the 1960s, when these anthologies were compiled. Exploration of this point is beyond the scope of the present study.

6 Hartley to Stieglitz, May 1913, YCAL.

7 Hartley to Stieglitz, February 1913, YCAL.

8 Hartley to Franz Marc, May 13, 1913, Franz Marc Papers, Archiv für Bildende Kunst, Germanisches Nationalmuseum, Nuremberg. As quoted in Patricia McDonnell, ed. "Marsden Hartley's Letters to Franz Marc and Wassily Kandinsky, 1913–1914," *Archives of American Art Journal* 29, nos. 1 and 2 (1989): 38.

9 Hartley, "Art—and the Personal Life," 71.

10 Proust as quoted in H. Stuart Hughes, *Consciousness and Society: The Reorientation of European Social Thought, 1890–1930* (New York: Alfred A. Knopf, 1958), 362.

11 Hartley to Horace Traubel, February 10, 1907. As quoted in William Innes Homer, ed. *Heart's Gate: Letters between Marsden Hartley and Horace Traubel, 1906–1915* (Highlands, N.C.: Jargon Society, 1982), 24.

12 For analysis of the goals and cultural context of American impressionism, see Kathleen A. Pyne, "Immanence, Transcendence, and Impressionism in Late-Nineteenth-Century American Painting," Ph.D. diss., University of Michigan, 1989.

13 Hartley to Anne Traubel, May 31, 1911. As quoted in Homer, *Heart's Gate*, 76.

14 Ibid., 77.

15 Marsden Hartley, *Somehow a Past: The Autobiography of Marsden Hartley*, ed. Susan Ryan (Cambridge, Mass.: MIT Press, 1997), 181. Prior to the publication of this book, the autobiography existed in manuscript form and was only accessible at YCAL.

16 Dewey as quoted in Gail R. Scott, "Introduction," *On Art by Marsden Hartley*, 25.

17 Ralph Waldo Emerson, *Selections from Ralph Waldo Emerson*, Stephen E. Whicher, ed. (Boston: Houghton, Mifflin, 1957), 49.

18 Ralph Waldo Emerson, *The Essays of Ralph Waldo Emerson*, A. R. Ferguson and J. F. Carr, eds. (1841, 1844; repr. Cambridge, Mass.: Harvard University Press, 1987), 323.

19 Emerson, *Selections*, 40.

20 Matthew Baigell, "American Landscape Painting and National Identity: The Stieglitz Circle and Emerson," *Art Criticism* 4, no. 1 (1987): 38.

21 Hartley to Norma Berger, July 11, 1910, YCAL.

22 Hartley to Stieglitz, June 1911, YCAL.

23 Hartley to Stieglitz, September 28 and February 1913, YCAL.

24 Marsden Hartley, "Whitman and Cézanne," in *Adventures in the Arts* (1921; repr. New York: Hacker Art Books, 1972), 33. Hartley equated Whitman and Cézanne in his September 28, 1913, letter to Stieglitz. In slightly later correspondence, he informed Stieglitz that he had been recording his ideas in essay form. Hartley's 1921 publication of the "Whitman and Cézanne" essay is very likely a revised version of this same, much earlier manuscript.

25 Gertrude Stein to Marsden Hartley, n.d. (1913). Hartley to Stieglitz, n.d. (1913), YCAL.

26 Hartley to Stieglitz, October 22, 1913, YCAL.

27 Ibid.

28 Wendy Steiner, *Exact Resemblance to Exact Resemblance: The Literary Portraiture of Gertrude Stein* (New Haven: Yale University Press, 1978), 40.

29 Gertrude Stein, *The Making of the Americans* (1925; condensed version, New York: Harcourt, Brace, 1934), 230.

30 Hartley to Gertrude Stein, October 18, 1913, YCAL.

31 Hartley to Stieglitz, October 22, 1913, YCAL.

32 Hartley to Stieglitz, February 1913, YCAL.

33 William James, *Essays in Radical Empiricism* (1912; Cambridge, Mass.: Harvard University Press, 1976), 22; and idem., *The Principles of Psychology*, 3 vols. (1890; repr. Cambridge, Mass.: Harvard University Press, 1981), 1: 185.

34 William James, *The Varieties of Religious Experience* (1902; repr. New York: Penguin Books, 1987), 423, 427. Hartley also would have responded positively to these lines of James: "Our normal waking consciousness, rational consciousness as we call it, is but one special type of consciousness, whilst all about it, parted from it by the filmiest of screens, there lie potential forms of consciousness entirely different. . . . No account of the universe in its totality can be final, which leaves these other forms of consciousness quite disregarded." James, *Religious Experience*, 388.

35 James, *Radical Empiricism*, 6–7.

36 Ibid., 4.

37 Townsend Ludington, *Marsden Hartley: The Biography of an American Artist* (Boston: Little, Brown, 1992), 111. Gail Scott was the first to present an insightful analysis of Hartley's absorption of Jamesian ideas. See her "Introduction," *On Art by Marsden Hartley*, 19–57.

38 Gail Scott wrote that James' book was Hartley's impetus for reading broadly in spiritualist literature in 1912. See her *Marsden Hartley* (New York: Abbeville Press, 1988), 39.

39 Arnold Rönnebeck's private journals, 1910–1912, YCAL.

40 Hartley to Stieglitz, February 1913, YCAL.

41 Ibid.

42 Hartley to Stieglitz, December 20, 1912, and November 1912, YCAL.

43 Hartley, *Somehow a Past*, 83.

44 See Patricia McDonnell, "El Dorado: Marsden Hartley in Imperial Berlin," in *Dictated by Life: Marsden Hartley's German Paintings and Robert Indiana's Hartley Elegies* (Minneapolis: Frederick R. Weisman Art Museum, University of Minnesota, 1995), 15–42.

45 Hartley to Stieglitz, February 1913, YCAL.

46 Hartley to Stieglitz, May 1913, YCAL.

47 Ibid. For documentation and analysis of the Wilhelmine German military and its well-known role as a haven and community for gay men, and for Hartley's relationship to members of the military in Berlin, see Patricia McDonnell, "El Dorado," *Dictated by Life*.

48 Hartley to Stieglitz, May 1913, YCAL.

49 See Patricia McDonnell, "'Essentially masculine': Marsden Hartley, Gay Identity, and the Wilhelmine German Officer," *Art Journal* 56, no. 2 (Summer 1997).

50 Marsden Hartley, "Foreword to His Exhibition," *Camera Work* no. 45 (January 1914): 17. As quoted in *On Art by Marsden Hartley*, 62–63.

51 Preceding three quotations: Hartley to Stieglitz, August 1913, February 1913, and September 28, 1913, YCAL. Hartley's comment on the War Motif paintings as quoted in "American Artist Astounds Germans," *New York Times* (December 19, 1915), sec. 6, p. 4. This is a review of Hartley's 1915 exhibition at Berlin's Haas-Haye Galerie. The quote is from the artist's statement accompanying the exhibition.

52 Hartley to Stieglitz, August 5, 1915, YCAL.

53 Marsden Hartley, "Foreword," *Camera Work* no. 48 (October 1916): 12.

54 For analysis of the strong pro-German sentiment in the United States before 1914 and its sharp reversal following the onset of World War I, see Patricia McDonnell, "American Impressions of Germany and German Culture at the Turn of the Century," in *Painting Berlin Stories: Oscar Bluemner, Marsden Hartley, and the First American Avant-Garde in Expressionist Berlin, 1905–1915* (New York and Frankfurt: Peter Lang Publishing, 1997).

55 Unidentified speaker as quoted in Stanley Cooperman, *World War I and the American Novel* (Baltimore: Johns Hopkins Press, 1967), 24.

56 Robert K. Martin was the first to suggest this point. See his "Reclaiming Our Lives," *Christopher Street* 4, no. 7 (June 1980): 32–38. See also Jonathan Weinberg, *Speaking for Vice: Homosexuality in the Art of Charles Demuth, Marsden Hartley, and the First American Avant-Garde* (New Haven: Yale University Press, 1993), 157.

57 Henry McBride, "Current News of Art and the Exhibitions," *New York Sun* (April 9, 1916), sec. 6, p. 8. As quoted in *Camera Work* no. 48 (October 1916): 58.

58 Barbara Haskell, *Marsden Hartley*, exh. cat. (New York: Whitney Museum of American Art and New York University Press, 1980), 52.

59 Hartley to Stieglitz, March 15, 1915, YCAL.

60 R. J .Q. Adams, ed. *The Great War, 1914–18: Essays on the Military, Political, and Social History of the First World War* (College Station, Tex.: Texas A&M University Press, 1990), 2.

61 Stein as quoted in Michael E. Parrish, *Anxious Decades: America in Prosperity and Depression, 1920–1941* (New York and London: W. W. Norton, 1992), ix.

62 George Mosse, *Fallen Soldiers: Reshaping the Memory of the World Wars* (New York and Oxford: Oxford University Press, 1990), 3.

63 Ibid., 4.

64 *Encyclopedia Americana*, vol. 6 (Danbury, Conn.: Grolier, 1995), 811.

65 A. J. P. Taylor, *The First World War* (London: Hamish Hamilton, 1963), 22.

66 Paul Fussell, *The Great War and Modern Memory* (London, Oxford, and New York: Oxford University Press, 1975), 12–13.

67 Mosse, *Fallen Soldiers*, 4.

68 Graves as quoted in Alfred W. Crosby, *America's Forgotten Pandemic: The Influenza of 1918* (New York and Cambridge, England: Cambridge University Press, 1989), 17.

69 Unidentified reporter as quoted in *America's Forgotten Pandemic*, 320.

70 Fussell, *The Great War and Modern Memory*, 13.

71 Trevor Wilson, "The Significance of the First World War," in *The Great War, 1914–1918*, 19.

72 James as quoted in Fussell, *The Great War and Modern Memory*, 8.

73 Hemingway as quoted in Fussell, *The Great War and Modern Memory*, 21.

74 Hartley to Gertrude Stein, n.d. (1915), YCAL.

75 James Mellow, *Charmed Circle: Gertrude Stein and Company* (New York: Avon Books, 1982), 328–329.

76 Paul Fussell, "Introduction: On Modern War," *The Bloody Game: An Anthology of Modern War* (London: Scribners, 1991), 23.

77 John Dos Passos, *The Ground We Stand On* (New York: Harcourt, Brace, 1941), 3.

78 See Peter Gay, *Weimar Culture: The Outsider as Insider* (New York: Harper and Row, 1968).

79 For an analysis of these trends and their manifestations in popular culture, see Michael Steiner, "Regionalism in the Great Depression," *Geographical Review* 73, no. 4 (October 1983): 430–446.

80 Ibid., 430–431.

81 Kenneth Silver, *Esprit de Corps: The Art of the Parisian Avant-Garde and the First World War, 1914–1925* (Princeton, N.J.: Princeton University Press, 1989).

82 André Lhote as quoted in Silver, *Esprit de Corps*, 146.

83 Julian Benda, *The Treason of the Intellectuals* (1928; repr. New York: W. W. Norton, 1969).

84 Steiner, "Regionalism," 434–435.

85 Harold Stearns, *Civilization in the United States: An Inquiry by Thirty Americans* (New York: Harcourt, Brace, 1922). As quoted in Robert Dorman, *Revolt of the Provinces: The Regionalist Movement in America, 1920–1945* (Chapel Hill, N.C., and London: University of North Carolina Press, 1993), 21.

86 For a second anthology of 1920s writings promoting pride in American places and regions, see Daniel H. Borus, ed., *These United States: Portraits of America from the 1920s* (Ithaca, N.Y.: Cornell University Press, 1992).

87 Unidentified critic as quoted in Matthew Baigell, "The Beginnings of 'The American Wave' and the Depression," *Art Journal* 27, no. 4 (Summer 1968): 390.

88 Steiner, "Regionalism," 438.

89 Willard Huntington Wright, *The Man of Promise* (New York and London: John Lane, 1916); and John T. Frederick, *Green Bush* (New York: Alfred A. Knopf, 1925).

90 Hartley to Stieglitz, February 8, 1917, YCAL. As quoted in Ludington, 134.

91 Hartley as quoted in Gail R. Scott, ed., *The Collected Poems of Marsden Hartley* (Santa Rosa, Calif.: Black Sparrow Press, 1987), 46.

92 Marsden Hartley, "America as Landscape," *El Palacio* 5 (December 21, 1918): 340.

93 Marsden Hartley, "Red Man Ceremonials: An American Plea for American Esthetics," *Art and Archaeology* 9, no. 1 (January 1920): 13.

94 Hartley, "America as Landscape," 342.

95 Hartley to Stieglitz, August 1, 1918, YCAL.

96 Hartley, "America as Landscape," 340.

97 Marsden Hartley, "The Scientific Esthetic of the Redman," *Art and Archaeology* 13 (March 1922): 118.

98 Hartley, "The Business of Poetry," 157.

99 Georgia O'Keeffe to Sherwood Anderson, February 11, 1924. As quoted in Jack Cowart, Juan Hamilton, and Sarah Greenough, *Georgia O'Keeffe: Art and Letters*, exh. cat. (Washington, D.C.: National Gallery of Art, 1987), 176.

100 Hartley, "Esthetic of the Redman" 119.

101 Scott, *On Art by Marsden Hartley*, 47.

102 Bruce Robertson, *Marsden Hartley* (New York: Harry N. Abrams in association with the National Museum of American Art, Smithsonian Institution, 1994), 98.

103 Hartley to Edith Halpert, July 12, 1933. As quoted in Garnett McCoy, ed., "Letters from Germany, 1933–1938," *Archives of American Art Journal* 25, nos. 1 and 2 (1985): 3–28.

104 See Donna Cassidy, "'On the Subject of Nativeness': Marsden Hartley and New England Regionalism," *Winterthur Portfolio* 29, no. 4 (Winter 1994): 227–245.

105 Marsden Hartley, "Is There an American Art?" (1938, unpublished). As quoted in Scott, *On Art by Marsden Hartley*, 199.

106 Hartley to Gertrude Stein, October 18, 1913, YCAL.

107 Hartley, *Somehow a Past*, 87.

108 Cassidy, "'On the Subject of Nativeness'": 234. For a full analysis of the connections between American nationalism and latent Romanticism in this period, see Timothy R. Rodgers, "Making the American Artist: John Marin, Alfred Stieglitz, and Their Critics, 1909–1936," Ph.D. diss., Brown University, 1994.

109 Hartley to Elizabeth Sparhawk Jones, October 23, 1939. As quoted in Ludington, *Marsden Hartley*, 270.

110 Benjamin Buchloh, "Figures of Authority, Ciphers of Regression: Notes on the Return to Representation in European Painting," *October* 16 (Spring 1981): 39–68.

Works in the Exhibition

Dimensions are in inches; height precedes width precedes depth.

Paintings by Marsden Hartley

1. *Maine Snowstorm,* 1908
oil on canvas, 30-1/8 x 30-1/8
Frederick R. Weisman Art Museum
Gift of Ione and Hudson Walker

2. *Summer,* 1908
oil on academy board, 9 x 11-7/8
Frederick R. Weisman Art Museum
Bequest of Hudson Walker from the Ione and Hudson Walker Collection

3. *Landscape No. 36,* 1908–1909
oil on canvas, 30-1/8 x 34
Frederick R. Weisman Art Museum
Bequest of Hudson Walker from the Ione and Hudson Walker Collection

4. *Autumn,* 1908
oil on canvas, 30-1/4 x 30-1/4
Frederick R. Weisman Art Museum
Bequest of Hudson Walker from the Ione and Hudson Walker Collection

5. *Autumn,* 1908
oil on academy board, 12 x 14
Frederick R. Weisman Art Museum
Bequest of Hudson Walker from the Ione and Hudson Walker Collection

6. *Songs of Winter,* circa 1908
oil on academy board, 8-7/8 x 11-7/8
Frederick R. Weisman Art Museum
Bequest of Hudson Walker from the Ione and Hudson Walker Collection

7. *Mountainside,* 1909
oil on academy board, 12 x 14
Frederick R. Weisman Art Museum
Bequest of Hudson Walker from the Ione and Hudson Walker Collection

8. *Deserted Farm,* 1909
oil on composition board, 24 x 20
Frederick R. Weisman Art Museum
Gift of Ione and Hudson Walker

9. *Landscape No. 14,* 1909
oil on academy board, 12 x 14
Frederick R. Weisman Art Museum
Bequest of Hudson Walker from the Ione and Hudson Walker Collection

10. *Waterfall,* 1910
oil on academy board, 12 x 12
Frederick R. Weisman Art Museum
Bequest of Hudson Walker from the Ione and Hudson Walker Collection

11. *Abstraction,* 1911
oil on paper on cardboard, 16-1/4 x 13
Frederick R. Weisman Art Museum
Gift of Ione and Hudson Walker

12. *Still Life: Fruit,* 1911
oil on canvas, 20-1/8 x 20-1/4
Frederick R. Weisman Art Museum
Bequest of Hudson Walker from the Ione and Hudson Walker Collection

13. *Still Life,* 1912
oil on composition board, 32-3/16 x 25-13/16
Frederick R. Weisman Art Museum
Bequest of Hudson Walker from the Ione and Hudson Walker Collection

14. *Abstraction with Flowers*, 1913
oil on canvas, 39-1/2 x 31-7/8
Frederick R. Weisman Art Museum
Bequest of Hudson Walker from the Ione and Hudson Walker Collection

15. *Portrait*, circa 1914–1915
oil on canvas, 32-1/4 x 21-1/2
Frederick R. Weisman Art Museum
Bequest of Hudson Walker from the Ione and Hudson Walker Collection

16. *Elsa*, 1916
oil on paper mounted on cardboard, 20 x 16
Frederick R. Weisman Art Museum
Bequest of Hudson Walker from the Ione and Hudson Walker Collection

17. *One Portrait of One Woman*, 1916
oil on composition board, 30 x 25
Frederick R. Weisman Art Museum
Bequest of Hudson Walker from the Ione and Hudson Walker Collection

18. *Movement, No. 11*, circa 1917
oil on wood panel, 20-1/16 x 15-3/4
Frederick R. Weisman Art Museum
Bequest of Hudson Walker from the Ione and Hudson Walker Collection

19. *Still Life No. 9*, 1917
oil on beaverboard, 24 x 20
Frederick R. Weisman Art Museum
Bequest of Hudson Walker from the Ione and Hudson Walker Collection

20. *Santos, New Mexico*, 1918–1919
oil on composition board, 31-3/4 x 23-3/4
Frederick R. Weisman Art Museum
Bequest of Hudson Walker from the Ione and Hudson Walker Collection

21. *New Mexico Landscape*, 1919
oil on canvas, 18-1/4 x 24-1/4
Frederick R. Weisman Art Museum
Bequest of Hudson Walker from the Ione and Hudson Walker Collection

22. *Floral Life: Debonair*, circa 1920
oil on canvas, 22 x 16
Frederick R. Weisman Art Museum
Bequest of Hudson Walker from the Ione and Hudson Walker Collection

23. *Western Flame*, 1920
oil on canvas, 22 x 31-7/8
Frederick R. Weisman Art Museum
Bequest of Hudson Walker from the Ione and Hudson Walker Collection

24. *Still Life*, 1923
oil on canvas, 20-1/2 x 24-1/4
Frederick R. Weisman Art Museum
Bequest of Hudson Walker from the Ione and Hudson Walker Collection

25. *Basket and Napkin*, 1923
oil on canvas, 14 x 25-5/8
Frederick R. Weisman Art Museum
Bequest of Hudson Walker from the Ione and Hudson Walker Collection

26. *Three Red Fish with Lemons*, 1924
oil on canvas, 14 x 25-5/8
Frederick R. Weisman Art Museum
Bequest of Hudson Walker from the Ione and Hudson Walker Collection

27. *Landscape, Vence*, 1925–1926
oil on canvas, 25-1/2 x 31-7/8
Frederick R. Weisman Art Museum
Bequest of Hudson Walker from the Ione and Hudson Walker Collection

28. *Still Life No. 14*, 1926
oil on canvas, 22-1/4 x 28
Frederick R. Weisman Art Museum
Bequest of Hudson Walker from the Ione and Hudson Walker Collection

29. *Peasant's Paradise*, 1926–1927
oil on canvas, 19-3/4 x 24
Frederick R. Weisman Art Museum
Bequest of Hudson Walker from the Ione and Hudson Walker Collection

30. *Fleurs d'Orphée*, 1928
oil on canvas, 21-11/16 x 13
Frederick R. Weisman Art Museum
Bequest of Hudson Walker from the Ione and Hudson Walker Collection

31. *Eight Bells Folly: Memorial to Hart Crane*, 1933
oil on canvas, 30-5/8 x 39-3/8
Frederick R. Weisman Art Museum
Gift of Ione and Hudson Walker

32. *Dogtown, the Last of the Stone Wall*, 1934
oil on academy board, 17-3/4 x 24-1/16
Frederick R. Weisman Art Museum
Bequest of Hudson Walker from the Ione and Hudson Walker Collection

33. *Dogtown*, 1934
oil on Masonite, 16 x 28-7/8
Frederick R. Weisman Art Museum
Bequest of Hudson Walker from the Ione and Hudson Walker Collection

34. *Adelard the Drowned, Master of the "Phantom,"* circa 1938–1939
oil on academy board, 27-7/8 x 22
Frederick R. Weisman Art Museum
Bequest of Hudson Walker from the Ione and Hudson Walker Collection

35. *Finnish-Yankee Sauna*, 1938–1939
oil on academy board, 24 x 18
Frederick R. Weisman Art Museum
Bequest of Hudson Walker from the Ione and Hudson Walker Collection

36. *Marie Ste. Esprit*, circa 1938–1939
oil on academy board, 28 x 22
Frederick R. Weisman Art Museum
Bequest of Hudson Walker from the Ione and Hudson Walker Collection

37. *North Atlantic Harvest*, 1938–1939
oil on academy board, 20-1/2 x 26-1/2
Frederick R. Weisman Art Museum
Bequest of Hudson Walker from the Ione and Hudson Walker Collection

Works on Paper by Marsden Hartley

38. *Self-Portrait*, circa 1908
charcoal on cream wove paper, 12 x 9
Frederick R. Weisman Art Museum
Bequest of Hudson Walker from the Ione and Hudson Walker Collection

39. *New Mexico*, circa 1918
pastel on paper, 17-11/16 x 28-1/4
Frederick R. Weisman Art Museum
Bequest of Hudson Walker from the Ione and Hudson Walker Collection

40. *Arroyo Hondo, Valdez*, 1918
pastel on paper, 17-1/4 x 27-5/8
Frederick R. Weisman Art Museum
Bequest of Hudson Walker from the Ione and Hudson Walker Collection

41. *New Mexico Landscape*, 1918
pastel on paper, 12-1/4 x 18-1/4 (irregular)
Frederick R. Weisman Art Museum
Bequest of Hudson Walker from the Ione and Hudson Walker Collection

42. *Landscape No. 8*, 1919
pastel on paper, 17-5/8 x 27-7/8
Frederick R. Weisman Art Museum
Bequest of Hudson Walker from the Ione and Hudson Walker Collection

43. *Whale's Jaw, Dogtown, No. 1*, 1931
black lithographic crayon on cream tracing paper, 12-11/16 x 16-1/8
Frederick R. Weisman Art Museum
Bequest of Hudson Walker from the Ione and Hudson Walker Collection

44. *Alpspitze, Garmisch-Partenkirchen*, 1933
pastel on rose paper, 8-3/4 x 11-7/8
Frederick R. Weisman Art Museum
Bequest of Hudson Walker from the Ione and Hudson Walker Collection

45. *The Waxenstein, Garmisch-Partenkirchen*, 1933
pastel on gray paper, 20-1/8 x 15-11/16
Frederick R. Weisman Art Museum
Bequest of Hudson Walker from the Ione and Hudson Walker Collection

46. *New England Fisherman*, 1937
black crayon on tan cardboard, 26 x 10-3/16
Frederick R. Weisman Art Museum
Bequest of Hudson Walker from the Ione and Hudson Walker Collection

47. *Fishing Shack and Lobster Pots*, 1937
lithographic crayon and white chalk on gray cardboard, 18-3/4 x 25-7/8
Frederick R. Weisman Art Museum
Bequest of Hudson Walker from the Ione and Hudson Walker Collection

48. *Fishing Village*, 1937
lithographic crayon and white chalk on gray cardboard, 10-1/4 x 26
Frederick R. Weisman Art Museum
Bequest of Hudson Walker from the Ione and Hudson Walker Collection

49. *Seated Male Nude*, circa 1939
pastel on cream laid paper, 22-3/4 x 17-1/4
Frederick R. Weisman Art Museum
Bequest of Hudson Walker from the Ione and Hudson Walker Collection

50. *Female Figure (Reclining)*, 1939
pastel on gray charcoal paper, 19-3/4 x 15-7/8
Frederick R. Weisman Art Museum
Bequest of Hudson Walker from the Ione and Hudson Walker Collection

51. *Dead Plover*, 1940
black lithographic crayon, gray, brown, and white chalks on charcoal
paper, 17-13/16 x 11-3/4
Frederick R. Weisman Art Museum
Bequest of Hudson Walker from the Ione and Hudson Walker Collection

52. *Mount Katahdin*, 1940–1941
black crayon on buff wove paper, 11-1/4 x 14
Frederick R. Weisman Art Museum
Bequest of Hudson Walker from the Ione and Hudson Walker Collection

53. *Dead Plover*, 1940
pastel on gray cardboard, 10-1/8 x 26
Frederick R. Weisman Art Museum
Bequest of Hudson Walker from the Ione and Hudson Walker Collection

Related Works

54. Alfred Stieglitz (American, 1864–1946)
Portrait of Marsden Hartley, 1913–1915
platinum print, 9-7/8 x 8
Frederick R. Weisman Art Museum
Gift of Ione and Hudson Walker

55. Arnold Rönnebeck (American, b. Germany, 1885–1947)
Head of Hartley, 1923
terracotta, 21-1/2 x 19-1/2 x 10
Frederick R. Weisman Art Museum
Bequest of Hudson Walker from the Ione and Hudson Walker Collection

56. Jacques Lipchitz (American, b. Lithuania, 1891–1973)
Portrait of Marsden Hartley, 1942
bronze, 15 x 9-1/4 x 13
Frederick R. Weisman Art Museum
Bequest of Hudson Walker from the Ione and Hudson Walker Collection

CHRONOLOGY

Marsden Hartley, Self-Portrait, circa 1908.
Charcoal on cream wove paper, Frederick R. Weisman Art
Museum, Bequest of Hudson Walker from the Ione and Hudson
Walker Collection.

1877
Born Edmund Hartley January 4 in Lewiston, Maine.
Thomas Edison invents hand-cranked "phonograph or speaking machine"; patents incandescent vacuum light bulb two years later.

1883
Brooklyn Bridge completed.

1885
Mother, Eliza Jane Hartley, dies March 4.

1889
Father marries Martha Marsden August 20 and moves to Cleveland; Edmund remains with sister in Auburn, Maine.

1893
Moves to Cleveland and joins father and stepmother.
Henry Ford road-tests his first motorcar in April.

1895
First theater showing of motion pictures in Paris.

1896
Begins art lessons with John Semon, a Cleveland painter.

1898
Begins classes at Cleveland School of Art (now Cleveland Institute of Art).
Spanish-American War fought.

1899
Receives five-year scholarship to study art in New York and enrolls in fall at New York School of Art (formerly Chase School of Art); summers in Maine for next seven years.
Aspirin invented in Germany.

1900
Leaves New York School of Art for National Academy of Design, where he studies for four years.
Construction of New York subway system begins.

1901
Guglielmo Marconi receives first transatlantic wireless message December 12 in Newfoundland.

1903
Orville and Wilbur Wright make first sustained manned flight in gasoline-powered aircraft December 17 at Kitty Hawk, North Carolina.

1905
Meets Horace Traubel, Walt Whitman's biographer and disciple.
Albert Einstein introduces his theory of relativity; the term fauve (wild beast) first used to characterize paintings by André Derain, Henri Matisse, Maurice Vlaminck, and others displayed at Salon d'Automne in Paris.

1906
Adopts stepmother's maiden surname, Marsden, as his first name.

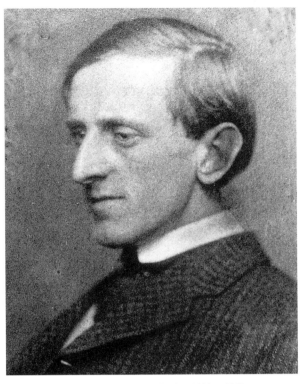

Anonymous, Marsden Hartley, 1908 or 1909.
Photograph, Bates College Museum of Art, Marsden Hartley Memorial Collection.

Marsden Hartley, Self-Portrait as a Draughtsman, 1908–1909.
Crayon on paper, Allen Memorial Art Museum, Oberlin College, Oberlin, Ohio, Gift of the Oberlin College Class of 1945.

78

Marsden Hartley, Self-Portrait, circa 1908.
Black crayon on wove paper laid on Bristol board, National
Gallery of Art, Washington, D.C., John Davis Hatch Collection,
Avalon Fund.

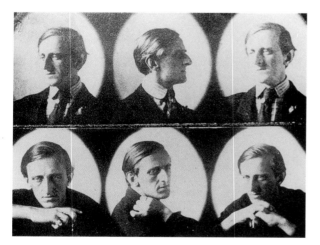

Anonymous, Marsden Hartley, 1909.
Photograph, Bates College Museum of Art, Marsden Hartley
Memorial Collection.

1907

Begins late-impressionist landscapes; puts up tents for
Congress of Religions at Green Acre, a summertime
mystical-intellectual retreat in Eliot, Maine; first one-
person exhibition in home of Mrs. Ole Bull in Eliot.
Pablo Picasso paints groundbreaking cubist work Les
Demoiselles d'Avignon; *first Ziegfeld Follies staged
in New York.*

1908

Exhibits at Rowlands Gallery in Boston.

1909

Maurice and Charles Prendergast view his work in
Boston and write letters of introduction to William
Glackens, of The Eight, in New York; meets Alfred
Stieglitz through Seumas O'Sheel in April; first one-
person show at Stieglitz's gallery, 291, in May;
receives weekly stipend from dealer N. E. Montross
for next two years; completes Dark Mountain series,
inspired by Albert Pinkham Ryder.
Admiral Robert E. Peary reaches North Pole April 9.

1910

Sees Matisse and Rodin exhibitions at 291; palette
changes to bright colors of fauvism.

1911

Sees Picasso exhibition at 291; sees Cézanne paintings
in Havemeyer collection; experiments with modernist
compositions inspired by Picasso and Cézanne.
*Pioneering abstract paintings produced by Arthur
Dove and Wassily Kandinsky; Roald Amundsen
reaches South Pole December 14.*

1912

Second one-person exhibition at 291 in February;
travels to Europe for first time, arriving in Paris
April 11; meets Leo and Gertrude Stein; joins German
coterie at Restaurant Thomas and befriends Arnold
Rönnebeck and Karl von Freyburg; begins still lifes
inspired by Cézanne, followed by abstract works
inspired by his reading of William James and
Christian mystics.

1913

Visits Berlin and Munich in January; meets Kandinsky in Munich; moves to Berlin, arriving May 17; meets Franz Marc en route; exhibits in fall in *Erster Deutscher Herbstsalon*, international survey of vanguard art organized by Der Sturm gallery; paints abstractions of Berlin military pageantry; work included in Armory show in New York, February 17–March 15.

New York's sixty-story Woolworth Building completed.

1914

Travels to New York in January for third one-person exhibition at 291; returns to Berlin via London and Paris; begins Amerika series, containing Native American imagery; hears of father's August 4 death in late September; friend Karl von Freyburg killed on Western Front October 7; begins War Motif paintings in November.

World War I erupts July 28 when Austria-Hungary declares war on Serbia; Panama Canal opens August 3; elastic brassiere and tear gas invented.

1915

Continues War Motif series; stepmother dies in May; mounts one-person exhibition, including forty-five works, at Galerie Haas-Haye in Berlin in October; war forces his return to United States in December.

Army tank invented (introduced in combat the next year in Battle of the Somme); long-distance telephone service between New York and San Francisco begins.

1916

Work included in *The Forum* exhibition at Anderson Galleries in March; fourth one-person exhibition at 291 in April; German paintings not well received; summers in Provincetown as guest of John Reed; travels to Bermuda in December with Charles Demuth; first essays appear in *New Republic* and *Seven Arts*.

1917

Returns from Bermuda to New York in May; summers in Maine.

United States enters World War I April 6; Bolsheviks, led by V. I. Lenin, seize power in Russia.

Alfred Stieglitz, Marsden Hartley, 1911.
Photograph, Yale Collection of American Literature, Beinecke Rare Book and Manuscript Library, Yale University.

Alfred Stieglitz, Portrait of Marsden Hartley, 1913–1915.
Platinum print, Frederick R. Weisman Art Museum, Gift of Ione and Hudson Walker.

Wesley Bradfield, Marsden Hartley, Randall Davey, and John Sloan Standing in front of the Palace of the Governors, Santa Fe, New Mexico, 1919. Photograph, Courtesy Museum of New Mexico, Santa Fe.

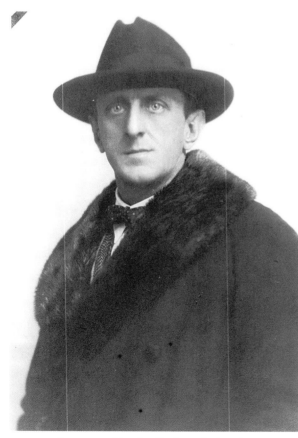

Anonymous, Marsden Hartley in Berlin, 1922. Photograph, Bates College Museum of Art, Marsden Hartley Memorial Collection.

1918

Travels to New Mexico at invitation of Mabel Dodge, arriving in Taos June 14; moves to Santa Fe November 6; writes articles on American landscape and Native Americans; first publication of his poetry.
Armistice ends World War I November 11.

1919

Travels to California, where he meets theorist-educator Arthur Wesley Dow, writer-publisher Robert McAlmon, and artist Carl Sprinchorn in winter; spends summer and fall in New Mexico, departing for New York November 19; stops en route in Chicago, where he visits Sherwood Anderson and Harriet Monroe.
Bauhaus founded in Weimar, Germany.

1920

Involved in New York Dada circle, whose members include Marcel Duchamp, Katherine Dreier, and Man Ray; works on first issue of *Contact* magazine with Robert McAlmon and William Carlos Williams.
Prohibition and women's suffrage become Constitutional law in United States.

1921

Publishes anthology of his essays, *Adventures in the Arts*; New York auction at Anderson Galleries raises funds that help support him for several years; returns to Berlin in November, visiting Paris en route.

1922

Prints series of lithographs.

1923

Twenty-five Poems published by McAlmon's Paris-based Contact Editions; begins painting series, New Mexico Recollections; tours Italy in fall.
Adolf Hitler, head of new National Socialist German Workers' party, stages "Beer Hall Putsch" in Munich November 8 and temporarily seizes city government.

1924

Returns to New York in February; forms syndicate of collectors whose support provides him with stipend

for four years; travels to Paris, arriving July 25.

Josef Stalin succeeds Lenin as leader of Soviet Union.

1925

Begins one-year lease on house in Vence, France, in August.

Scribner's publishes F. Scott Fitzgerald's The Great Gatsby.

1926

Moves to Aix-en-Provence in October; in December rents house that was formerly a studio of Cézanne.

Scottish inventor John Baird gives first successful demonstration of television; first motion picture with sound demonstrated.

1927

Begins Mont Sainte-Victoire paintings, inspired by Cézanne; travels to Paris, Berlin, and Hamburg in winter and spring.

Charles Lindbergh makes first solo, nonstop transatlantic flight May 20–21.

1928

Returns to New York in January; travels to Chicago for exhibition of his work and to Denver to visit Arnold Rönnebeck, now director of Denver Art Museum; summers in New Hampshire and Maine; travels to Paris in August and stays through winter.

First Academy Awards presented for motion-picture excellence.

1929

One-person exhibition at Alfred Stieglitz's Intimate Gallery in New York in January not well received; returns to Aix-en-Provence in April; travels in November to Marseilles, where he meets Hart Crane; continues on travels to Toulouse, Paris, London, Hamburg, Berlin, and Dresden.

Museum of Modern Art founded; coaxial cable invented; New York stock market crash October 29 triggers decade-long worldwide depression.

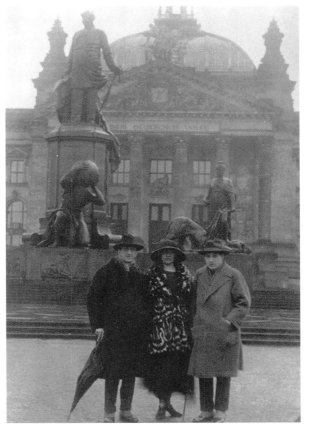

Anonymous, Marsden Hartley in front of Berlin's Reichstag, 1922. Photograph, Bates College Museum of Art, Marsden Hartley Memorial Collection.

Arnold Rönnebeck, Head of Hartley, 1923. Terracotta, Frederick R. Weisman Art Museum, Bequest of Hudson Walker from the Ione and Hudson Walker Collection.

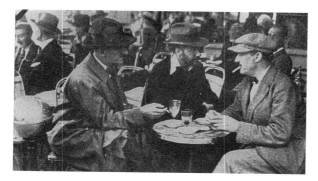

Anonymous, Marsden Hartley, Ezra Pound, and Fernand Léger in front of Café du Dome, 1924.
Photograph, Bates College Museum of Art, Marsden Hartley Memorial Collection.

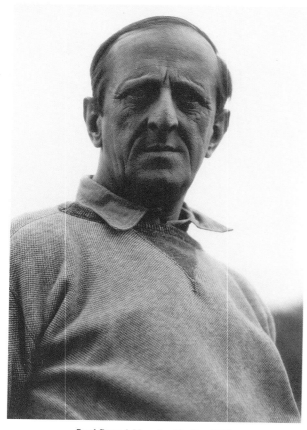

Paul Strand, Marsden Hartley, 1928.
Photograph, Yale Collection of American Literature, Beinecke Rare Book and Manuscript Library, Yale University.

1930

Returns to New York in March; Paul Strand's wife, Rebecca, types his essays about European experiences and travels; summers in New Hampshire.
Whitney Museum of American Art founded.

1931

Receives a Guggenheim fellowship in March, providing one year's support and requiring foreign residence; decides to live in Mexico; summers in Gloucester, Massachusetts, where he begins first of three series of Dogtown paintings depicting a local rock moraine.
Empire State Building, world's tallest structure in its day (1,250 feet, 102 stories), completed.

1932

Arrives in Mexico City in March; Hart Crane commits suicide in April on boat returning from Mexico to New York; moves to Cuernavaca in May to escape health problems brought on by Mexico City's altitude; reacquaints himself with occult literature through a friend's library of spiritualist texts.
Franklin D. Roosevelt elected president of United States.

1933

Exhibits work produced on Guggenheim fellowship at Galeria de la Escuela Central de Artes Plásticas in Mexico City in February; sails for Hamburg in April; travels to Bavarian Alps and Garmisch-Partenkirchen in September, remains through winter; hiking and reading inspire him to draw and paint mountain scenes; Gertrude Stein's *The Autobiography of Alice B. Toklas* published; Hartley begins his autobiography, *Somehow a Past.*
Hitler becomes chancellor of Germany; United States repeals Prohibition.

1934

Makes final return from Europe in February; establishes routine of wintering in New York and summering on Northeastern seaboard; returns to Gloucester in July and starts second Dogtown series.

1935

Destroys a hundred works of art January 4 when he can no longer afford storage bills and becomes very ill and depressed; travels to Bermuda in summer to recuperate; travels to Nova Scotia in September, boards with family of Francis and Martha Mason on Eastern Points Island.

Federal Art Project, part of New Deal's Works Progress Administration, established.

1936

One-person exhibition at Alfred Stieglitz's gallery An American Place in March well received; begins third series of Dogtown paintings from memory in Nova Scotia; Mason sons Donny and Alty and cousin Allan drown in storm September 19; stays on with devastated Mason family, returning to New York in December.

Spanish Civil War breaks out July 18; King Edward VII of England abdicates December 10 to marry American divorcée Wallis Simpson.

1937

Last one-person show at Stieglitz's gallery in April; essay "On the Subject of Nativeness—A Tribute to Maine" included in exhibition catalogue; Hudson D. Walker becomes Hartley's new dealer; moves to Portland, Maine, in fall.

1938

Holds first one-person exhibition at Hudson D. Walker Gallery in New York in February; summers on Vinalhaven Island, Maine; begins series of archaic portraits of Nova Scotia people and Albert Pinkham Ryder; moves to Boston for winter.

Germany annexes Austria; first color-television image transmitted; ballpoint pen, Teflon, and fluorescent lighting introduced.

1939

Second one-person exhibition at Hudson D. Walker Gallery in February features archaic portraits; summers in Maine, traveling to Portland, Lewiston, Auburn, West Brookville, Corea, and Bangor; climbs Mount Katahdin in October.

Jacques Lipchitz, Portrait of Marsden Hartley, 1942. Bronze, Frederick R. Weisman Art Museum, Bequest of Hudson Walker from the Ione and Hudson Walker Collection.

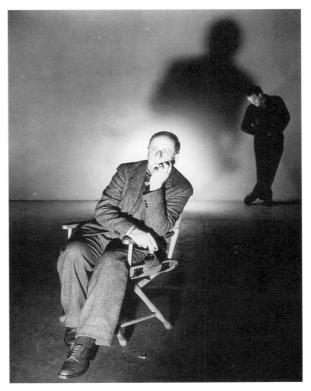

George Platt Lynes, Marsden Hartley, February 4, 1943. Photograph, George Platt Lynes Papers, Archives of American Art, Smithsonian Institution, Washington, D.C.

Marius de Zayas, Marsden Hartley, n.d.
Pen and ink and watercolor on paper, The Metropolitan Museum
of Art, The Alfred Stieglitz Collection, 1949.

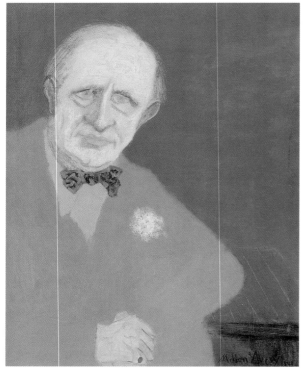

Milton Avery, Marsden Hartley, 1943.
Oil on canvas, The Hayden Collection, Courtesy Museum of
Fine Arts, Boston.

Germany invades Poland September 1, and Great Britain and France declare war two days later.

1940
Third solo show at Hudson D. Walker Gallery in March features his first Mount Katahdin paintings; boards with Forest and Katie Young in Corea, Maine, during summer; publishes *Androscoggin*, a collection of his poems.
Nylon introduced to mass market; Gone With the Wind wins Academy Award for Best Picture of 1939.

1941
Hudson D. Walker Gallery closes; Hartley finds representation with Macbeth Galleries; executes work featuring figures on beaches and seascapes; publishes second collection of poetry, *Sea Burial*; writes prose poem *Cleophas and His Own*, fictionalizing his Nova Scotia experiences; travels to Cincinnati for two-person exhibition with Stuart Davis at Cincinnati Art Museum.
Japan attacks Pearl Harbor December 7, and United States enters World War II the next day.

1942
First one-person exhibition at Paul Rosenberg and Company gallery in New York in November; Metropolitan Museum of Art awards Hartley a purchase prize in conjunction with its exhibition *Artists for Victory.*
Led by Enrico Fermi, Manhattan Project team produces first human-made atomic reaction.

1943
Paints in photographer George Platt Lynes' New York studio; returns to Corea, Maine, in July; dies of heart failure September 2 in Ellsworth, Maine.
Federal Art Project ends.

Selected Bibliography

Abrahams, Edward. "Alfred Stieglitz and/or Thomas Hart Benton." *Arts Magazine* 55, no. 10 (June 1981): 108–113.

Adams, R. J. Q., ed. *The Great War, 1914–1918: Essays on the Military, Political, and Social History of the First World War.* College Station, Tex.: Texas A&M University Press, 1990.

Baigell, Matthew. "The Beginnings of 'The American Wave' and the Depression." *Art Journal* 27, no. 4 (Summer 1968): 387–396, 398.

____. "American Art and National Identity: The 1920s." *Arts Magazine* 61, no. 6 (February 1987): 48–55.

____. "American Landscape Painting and National Identity: The Stieglitz Circle and Emerson." *Art Criticism* 4, no. 1 (1987): 27–47.

____. "The Influence of Whitman on Early Twentieth-Century American Painting." *The Mickle Street Review* 12 (1990): 99–113.

Barnett, Vivian Endicott. "Marsden Hartley's Return to Maine." *Arts Magazine* 54, no. 2 (October 1979): 172–176.

Bolle, Michael, and Rolf Bothe, eds. *Eldorado: Homosexuelle Frauen und Männer in Berlin, 1850–1950.* exh. cat. Berlin: Berlin Museum und Frölich und Kaufmann, 1984.

Borus, Daniel, ed. *These United States: Portraits of America from the 1920s.* Ithaca, N. Y., and London: Cornell University Press, 1992.

Buchloh, Benjamin. "Figures of Authority, Ciphers of Regression: Notes on the Return of Representation in European Painting." *October* 16 (Spring 1981): 39–68.

Buitenhuis, Peter. *The Great War of Words: British, American, and Canadian Propoganda and Fiction, 1914–1923.* Vancouver: University of British Columbia Press, 1987.

Burlingame, Robert. "Marsden Hartley's *Androscoggin:* Return to Place." *New England Quarterly* 31, no. 4 (December 1958): 447–462.

Cassidy, Donna. "'On the Subject of Nativeness': Marsden Hartley and New England Regionalism." *Winterthur Portfolio* 29, no. 4 (Winter 1994): 227–245.

Chauncey, George, Jr. *Gay New York: Gender, Urban Culture, and the Making of the Gay Male World, 1890–1940.* New York: Basic Books, 1994.

Cooperman, Stanley. *World War I and the American Novel.* Baltimore: Johns Hopkins Press, 1967.

Cork, Richard. *A Bitter Truth: Avant-Garde Art and the Great War.* exh. cat. New Haven: Yale University Press; and London: Barbican Art Gallery, 1994.

____. "Das Elend des Krieges: Die Kunst der Avantgarde und der Erste Weltkrieg." In *Die letzten Tagen der Menschheit: Bilder des Ersten Weltkrieges.* exh. cat. Berlin: Deutsches Historiches Museum and Ars Nicolai, 1994, 301–396.

Cotkin, George. *Reluctant Modernism: American Thought and Culture, 1880–1900.* New York: Twayne Publishing, 1992.

Cowling, Elizabeth, and Jennifer Mundy. *On Classical Ground: Picasso, Léger, De Chirico and the New Classicism, 1910–1930.* exh. cat. London: Tate Gallery, 1990.

Cross, Tim. *The Lost Voices of World War I: An International Anthology of Writers, Poets, and Playwrights.* London: Bloomsbury Publishing, 1988.

Dorman, Robert. *Revolt of the Provinces: The Regionalist Movement in America, 1920–1945.* London and Chapel Hill, N.C.: University of North Carolina Press, 1993.

Doss, Erika. *Benton, Pollock, and the Politics of Modernism: From Regionalism to Abstract Expressionism.* Chicago and London: University of Chicago Press, 1991.

Ekstein, Modris. *Rites of Spring: The Great War and the Birth of the Modern Age.* Boston: Houghton Mifflin, 1989.

____. "Der grosse Krieg: Versuch einer Interpretation." In *Die letzten Tagen der Menschheit: Bilder des Ersten Weltkrieges.* exh. cat. Berlin: Deutsches Historiches Museum and Ars Nicolai, 1994, 13–22.

Eldredge, Charles C. "Nature Symbolized: American Painting from Ryder to Hartley." In *The Spiritual in Art: Abstract Painting, 1890–1985.* exh. cat. Los Angeles: Los Angeles County Museum of Art; New York: Abbeville Press, 1986.

Emerson, Ralph Waldo. *The Essays of Ralph Waldo Emerson,* A. R. Ferguson and J. F. Carr, eds. 1841, 1844. Reprint, Cambridge, Mass.: Harvard University Press, 1987.

Ferguson, Gerald, ed. *Marsden Hartley and Nova Scotia.* exh. cat. Halifax, Nova Scotia: Mount Saint Vincent University Art Gallery, 1987.

Fussell, Paul. *The Great War and Modern Memory.* London, Oxford, and New York: Oxford University Press, 1975.

____. ed. *The Bloody Game: An Anthology of Modern War.* London: Scribners, 1991.

Gaehtgens, Thomas W. "Paris-München-Berlin. Marsden Hartley und die europäische Avantgarde." In *Kunst um 1800 und die Folgen.* Munich: Prestel Verlag, 1988.

Gallatin, A. E. *Art and the Great War.* New York: E. P. Dutton, 1919.

Gallup, Donald. "The Weaving of a Pattern: Marsden Hartley and Gertrude Stein." *Magazine of Art* 41, no. 7 (November 1948): 256–261.

Geldzahler, Henry. "World War I and the First Crisis in Vanguard Art." *Art News* 61, no. 8 (December 1962): 48–51.

Haskell, Barbara. *Marsden Hartley.* exh. cat. New York: Whitney Museum of American Art and New York University Press, 1980.

Hawley, Ellis. *The Great War and the Search for Modern Order: A History of the American People and Their Institutions, 1917–1933.* New York: St. Martin's Press, 1979.

Homer, William Innes. *Alfred Stieglitz and the American Avant-Garde.* Boston: New York Graphic Society, 1977.

____, ed. *Heart's Gate: Letters between Marsden Hartley and Horace Traubel, 1906–1915.* Highlands, N.C.: Jargon Society, 1982.

James, William. *The Varieties of Religious Experience.* 1902. Reprint, Cambridge, Mass.: Harvard University Press, 1987.

Katz, Jonathan Ned. *Gay American History: Lesbians and Gay Men in the U.S.A.* Rev. ed. New York: Meridien, 1992.

King, Lyndel. *Marsden Hartley, 1908–1942: The Ione and Hudson D. Walker Collection.* exh. cat. Minneapolis: University Art Museum, University of Minnesota, 1984.

Kirschke, James. *Willa Cather and Six Writers from the Great War.* Lanham, Maryland: University Press of America, 1991.

Lears, T. J. Jackson. *No Place of Grace: Antimodernism and the Transformation of American Culture, 1880–1920.* New York: Pantheon, 1981.

Levin, Gail. "Hidden Symbolism in Marsden Hartley's Military Pictures." *Arts Magazine* 54, no. 2 (October 1979): 154–158.

Ludington, Townsend. *Marsden Hartley: The Biography of an American Artist.* Boston: Little, Brown, 1992.

Martin, Robert K., ed. *The Continuing Presence of Walt Whitman.* Iowa City: University of Iowa Press, 1992.

May, Henry. *The Discontent of the Intellectuals: A Problem of the Twenties.* Chicago: Rand McNally, 1963.

McDonnell, Patricia. "Spirituality in the Art of Marsden Hartley and Wassily Kandinsky, 1910–1915." *Archives of American Art Journal* 29, nos. 1 and 2 (1989): 27–33.

____. "Indian Fantasy: Marsden Hartley's Myth of *Amerika* in Expressionist Berlin." *North Carolina Museum of Art Bulletin* 16 (1993): 50–64.

____. "El Dorado: Marsden Hartley in Imperial Berlin." In *Dictated by Life: Marsden Hartley's German Paintings and Robert Indiana's Hartley Elegies.* exh. cat. Minneapolis: Frederick R. Weisman Art Museum, University of Minnesota, 1995, 15–42.

____. *Painting Berlin Stories: Oscar Bluemner, Marsden Hartley, and the First American Avant-Garde in Expressionist Berlin, 1905–1915*. New York and Frankfurt: Peter Lang Publishing, 1997.

Mosse, George. *Nationalism and Sexuality: Respectability and Abnormal Sexuality in Modern Europe*. New York: Fertig, 1985.

____. *Fallen Soldiers: Reshaping the Memory of the World Wars*. New York and Oxford: Oxford University Press, 1990.

Over Here!: Modernism, The First Exile, 1914–1919. exh. cat. Providence, R.I.: David Winton Bell Gallery, Brown University, 1989.

Parrish, Michael E. *Anxious Decades: America in Prosperity and Depression, 1920–1941*. New York and London: W. W. Norton, 1992.

Pyne, Kathleen A. "Immanence, Transcendence, and Impressionism in Late-Nineteenth-Century American Painting." Ph.D. diss., University of Michigan, 1989.

Resek, Carl. *War and the Intellectuals: Essays by Randolph Bourne, 1915–1919*. New York and London: Harper and Row, 1964.

Robertson, Bruce. *Marsden Hartley*. New York: Harry N. Abrams with the National Museum of American Art, Smithsonian Institution, 1995.

Rodgers, Timothy R. "False Memories: Alfred Stieglitz and the Development of the Nationalist Aesthetic." In *Over Here!: Modernism, The First Exile, 1914–1919*. exh. cat. Providence, R.I.: David Winton Bell Gallery, Brown University, 1989, 59–66.

____. "Making the American Artist: John Marin, Alfred Stieglitz, and Their Critics, 1909–1936." Ph.D. diss., Brown University, 1994.

Rother, Rainer, ed. *Die letzten Tagen der Menschheit: Bilder des Ersten Weltkrieges*. exh. cat. Berlin: Deutsches Historiches Museum and Ars Nicolai, 1994.

Ryan, Susan, ed. *Somehow a Past: The Autobiography of Marsden Hartley*. Cambridge, Mass.: MIT Press, 1997.

Silver, Kenneth. *Esprit de Corps. The Art of the Parisian Avant-Garde and the First World War, 1914–1925*. Princeton, N.J.: Princeton University Press, 1989.

Scott, Gail R. "Marsden Hartley at Dogtown Common." *Arts Magazine* 54, no. 2 (October 1979): 159–165.

____. *Marsden Hartley: Visionary of Maine*. exh. cat. Presque Isle, Maine: University of Maine, 1982.

____, ed. *On Art by Marsden Hartley*. New York: Horizon Press, 1982.

____. *Marsden Hartley*. New York: Abbeville Press, 1988.

Somma, Thomas. "Thomas Hart Benton and Stuart Davis: Abstraction versus Realism in American Scene Painting." *Rutgers Art Review* 5 (Spring 1984): 46–55.

Stephen, Martin, ed. *Never Such Innocence: A New Anthology of Great War Verse*. London: Buchan and Enright, 1988.

Stott, William. *Documentary Expression and Thirties America*. 1973. Reprint, Chicago and London: University of Chicago Press, 1986.

Steiner, Michael. "Regionalism in the Great Depression," *Geographical Review* 73, no. 4 (October 1983): 430–446.

Steiner, Wendy. *Exact Resemblance to Exact Resemblance: The Literary Portraiture of Gertrude Stein*. New Haven: Yale University Press, 1978.

Tashjian, Dickran. "Marsden Hartley and the Southwest: A Ceremony for Our Vision, A Fiction for the Eye." *Arts Magazine* 54, no. 8 (April 1980): 127–131.

Udall, Sharyn. "Marsden Hartley." In *Modernist Painting in New Mexico, 1913–1935*. Albuquerque: University of New Mexico Press, 1984, 29–52.

____. "Southwest Phoenix: Marsden Hartley's Search for Self in New Mexico." In *Contested Terrain: Myth and Meaning in Southwest Art*. Albuquerque: University of New Mexico Press, 1996, 68–82.

Watkins, T. H. *The Great Depression: America in the 1930s*. Boston and New York: Little, Brown, 1993.

Watson, Steven. *Strange Bedfellows: The First American Avant-Garde*. New York: Abbeville Press, 1991.

Weinberg, Jonathan. *Speaking for Vice: Homosexuality in the Art of Charles Demuth, Marsden Hartley, and the First American Avant-Garde*. New Haven: Yale University Press, 1993.

Wertheim, Arthur. *The Little New York Renaissance: Iconoclasm, Modernism, and Nationalism in American Culture, 1908–1917*. New York: New York University Press, 1976.

Wohl, Robert. *The Generation of 1914*. Cambridge, Mass.: Harvard University Press, 1979.

____. "Introduction," *The Lost Voices of World War I: An International Anthology of Writers, Poets, and Playwrights*. Tim Cross, ed. London: Bloomsbury Publishing, 1988.